INTERWEAVE PRESENTS

CLASSIC CROCHET
BLANKETS

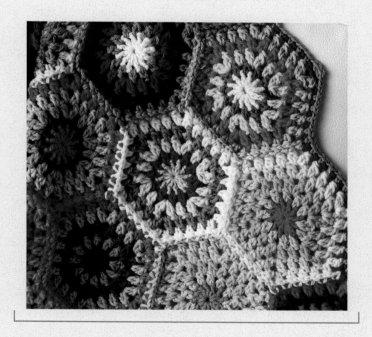

18 Timeless Patterns to Keep You Warm

 INTERWEAVE

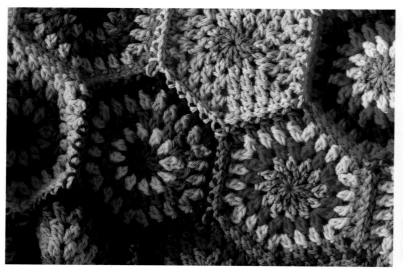
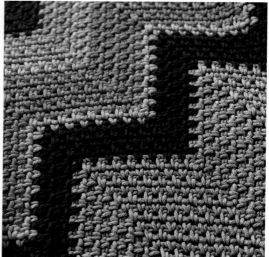

CONTENTS

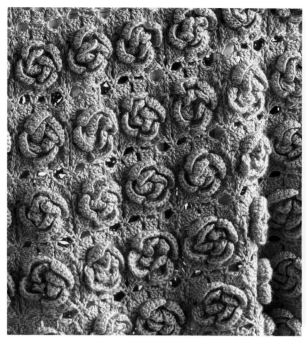
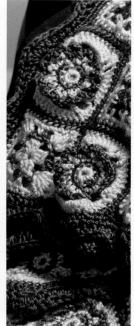
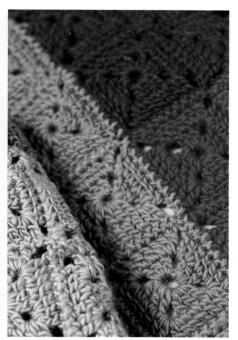

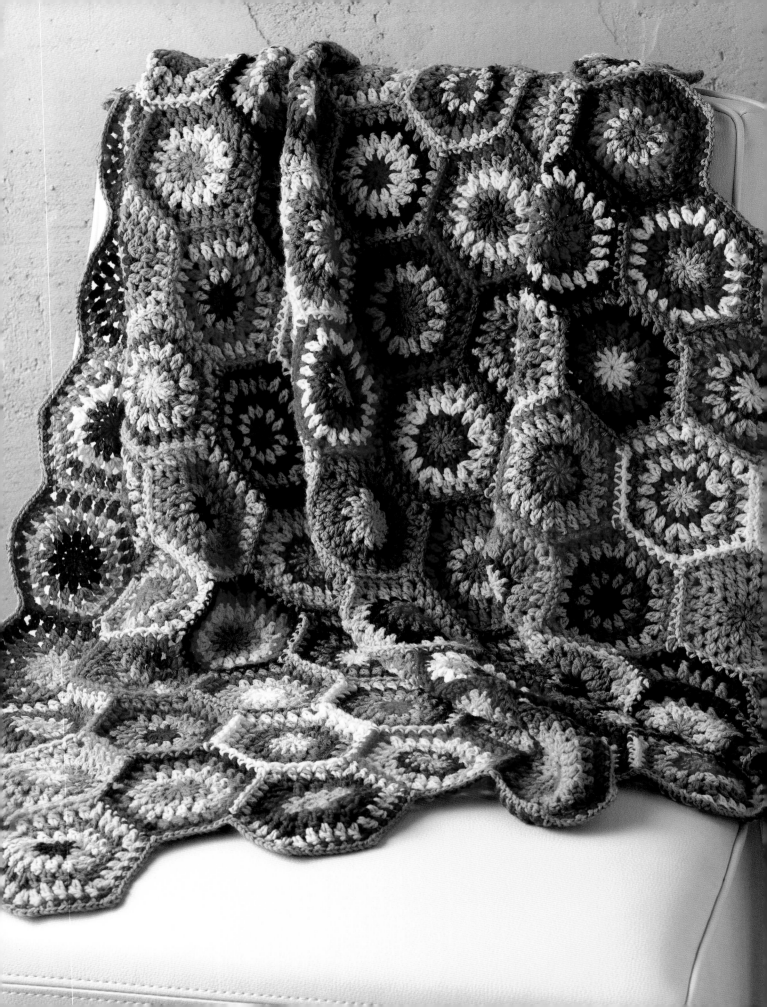

INTRODUCTION

Whether a chilly summer evening or a blustery winter day, nothing warms the body and soul like a blanket handmade with love. Cozy crochet blankets provide warmth and color throughout the house, from the bedroom, to the living room, to the nursery. Practical, timeless, and easy to make, you'll love the eighteen projects for crochet afghans, blankets, and throws in *Interweave Presents Classic Crochet Blankets.*

These classic crochet afghan patterns use a variety of crochet techniques. Crochet blankets are traditionally made one of three ways: working side to side in rows, working from the center out, or by joining motifs. From these foundations, a number of techniques can be used to create designs that range from homey and practical to stunning and sophisticated. Row by row, you can work unique striped effects or create a doily-inspired blanket with decorative lace details working from the center out. Classic granny squares are at the heart of motif-based afghans and just the start of what you can make when stitching together colorful motifs.

Crocheting a blanket is often the way beginner crocheters are introduced to crochet as a craft, and they quickly become their favorite type of project to make. In this collection of eighteen Interweave favorites, you can explore a variety of traditional techniques with stunning results.

So add a touch of personalization to your home, or get started on a gift for a special friend. *Interweave Presents Classic Crochet Blankets* provides all the instruction—and warmth—you need to get started.

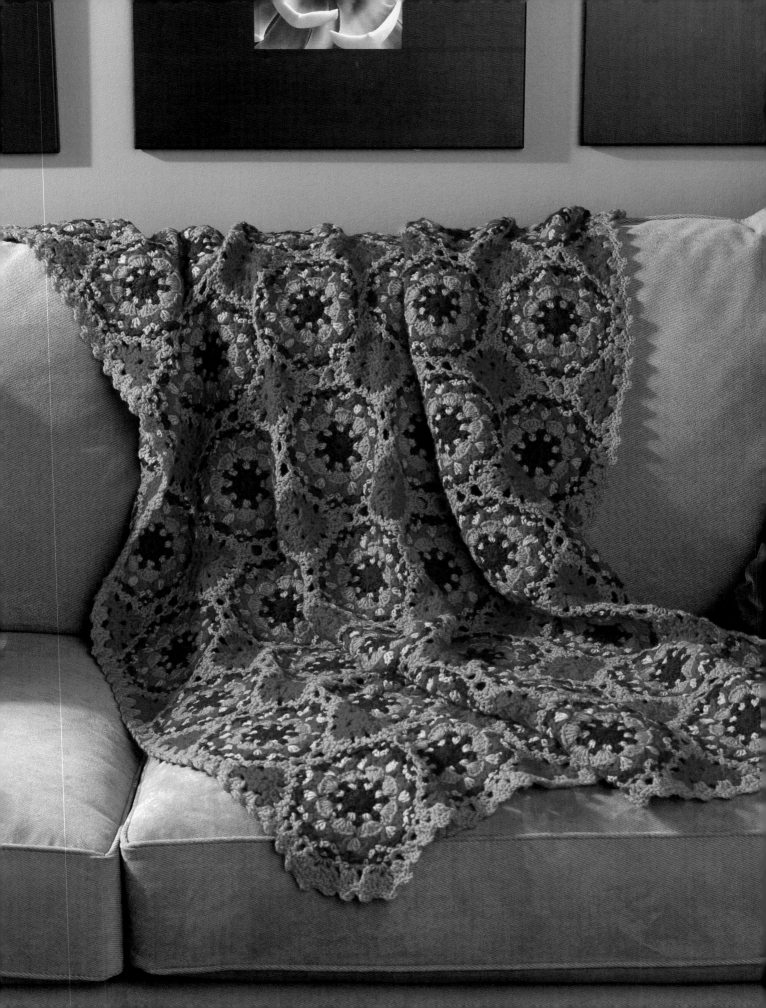

KALEIDOSCOPE
afghan

DESIGNED BY **TAMMY HILDEBRAND**

As a child, designer Tammy Hildebrand was fascinated looking into her toy kaleidoscope, watching the ever-changing designs appear. That memory was the inspiration behind this afghan. Designing each motif, she imagined lying in the grass on a summer day, twisting the end of the kaleidoscope to come up with a beautiful new design.

FINISHED SIZE
43" x 57" (109 x 145 cm).

YARN
Worsted weight
(#4 Medium).

SHOWN HERE: Universal Yarn Deluxe Worsted 100% Wool (100% wool; 220 yd [200 m] 3.5 oz [100 g]): #91475 sangria (A), 3 hanks; #12174 ginseng (B), 3 hanks; #41795 nectarine (C) 4 hanks; #3691 Christmas Red (D) 3 hanks.

HOOK
I/9 (5.5 mm) or size needed to obtain gauge.

NOTIONS
Tapestry needle for weaving in ends; spray bottle with water and straight pins for blocking.

GAUGE
Motif = 7" (18 cm) from flat side to flat side.

Filler = 3" x 3" (7.5 x 7.5 cm).

NOTES
✤ Do not turn at end of rnds unless otherwise instructed.

✤ Join each new color with RS facing.

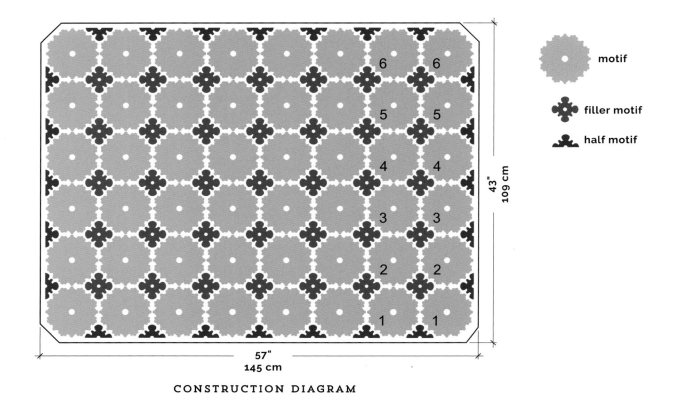

CONSTRUCTION DIAGRAM

STITCH GUIDE

Shell (sh) 3 dc in same sp or st.

Large Shell (lg-sh) 5 dc in same sp or st.

Ch-3 join Ch 1, drop lp from hook, insert hook in corresponding ch-3 sp on other motif, pick up dropped lp and draw through, ch 1.

Ch-5 join Ch 2, drop lp from hook, insert hook in corresponding ch-3 sp on other motif, pick up dropped lp and draw through, ch 2.

pattern

MOTIF (MAKE 48)

With A, ch 3, sl st in first ch to form a ring.

Rnd 1 (RS): Ch 3 (counts as dc), 15 dc in ring, sl st in top of beg ch to join—16 dc.

Rnd 2: Ch 1, sc in first st, ch 3, sk next st, *sc in next st, ch 3, sk next st; rep from * around, sl st in first sc to join, fasten off—8 sc, 8 ch-3 sps.

Rnd 3: Working behind ch-3 sps of previous rnd, join B with sl st in any skipped st, ch 3 (counts as dc), 2 dc in same st, ch 1, *sh (see Stitch Guide) in next skipped st, ch 1; rep from * around, sl st in top of beg ch to join, fasten off—8 sh, 8 ch-1 sps.

Rnd 4: Join C with sc in any ch-1 sp, working in ch-3 sp of Rnd 2 and center st of sh on Rnd 3 at the same time, lg-sh (see Stitch Guide) in next ch-3 sp and center st of next sh, *sc in next ch-1 sp, lg-sh in next ch-3 sp and center st of next sh; rep from * around, sl st in first sc to join, fasten off—8 lg-sh, 8 sc.

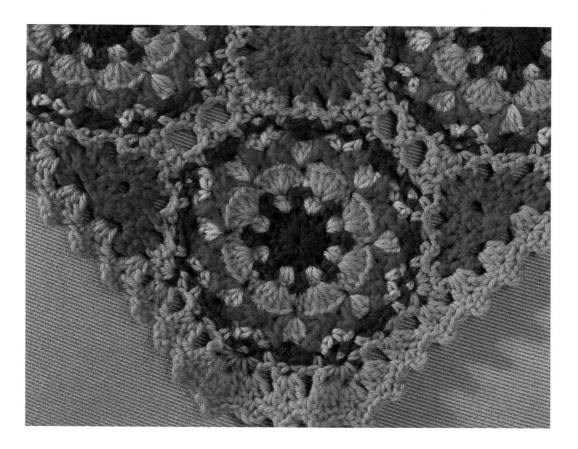

Rnd 5: Join D with sc in blo of center st of any lg-sh, (ch 3, sc) in blo of same st, (dc, ch 5, dc) in both lps of next sc, *(sc, ch 3, sc) in blo of center st of next lg-sh, (dc, ch 5, dc) in both lps of next sc; rep from * around, sl st in first sc to join, fasten off—8 ch-5 sp, 8 ch-3 sps.

Rnd 6: Join B with sc in any ch-3 sp, (ch 3, sc) in same sp, ch 1, working behind ch-5 sp between dc of Rnd 5, in same sc of Rnd 4, sh in next sc, ch 1, *(sc, ch 3, sc) in next ch-3 sp, ch 1, sh in next sc of Rnd 4, ch 1; rep from * around, sl st in first sc to join, fasten off—8 ch-3 sps, 8 sh.

Rnd 7: Join A with sc in any ch-3 sp, (ch 3, sc in same sp), ch 1, working in ch-5 sp of Rnd 5 and center st of sh on Rnd 6 at the same time, 5 sc in next sp and center st of next sh, ch 1, *(sc, ch 3, sc) in next ch-3 sp, ch 1, 5 sc in next sp and center st of next sh, ch 1; rep from * around, sl st in first sc to join, fasten off—8 ch-3 sps, 48 sc.

first strip

FIRST MOTIF ONLY

Rnd 8: Join C with sc in any ch-3 sp, (ch 3, sc) 3 times in same sp, sc in next ch-1 sp, sk next 2 sc, (sc, ch 3, sc) in blo of next sc, sc in next ch-1 sp, *(sc, [ch 3, sc] 3 times) in next ch-3 sp, sc in next ch-1 sp, sk next 2 sc, (sc, ch 3, sc) in blo of next sc, sc in next ch-1 sp; rep from * around, sl st in first sc to join, fasten off—64 sc, 32 ch-3 sps.

MOTIFS 2-8

Rnd 8: Join C with sc in any ch-3 sp, (ch 3, sc, [ch-3 join {see Stitch Guide}, sc] 2 times) in same sp, sc in next ch-1 sp, sk next 2 sc, (sc, ch-3 join, sc) in blo of next sc, sc in next ch-1 sp, ([sc, ch-3 join, sc] 2 times, ch 3, sc) in next ch-3 sp, sc in next ch-1 sp, sk next 2 sc, (sc, ch 3, sc) in blo of next sc, sc in next ch-1 sp, *(sc, [ch 3, sc] 3 times) in next ch-3 sp, sc in next ch-1 sp, sk next 2 sc, (sc, ch 3, sc) in blo of next sc, sc in next ch-1 sp; rep from * around, sl st in first sc to join, fasten off.

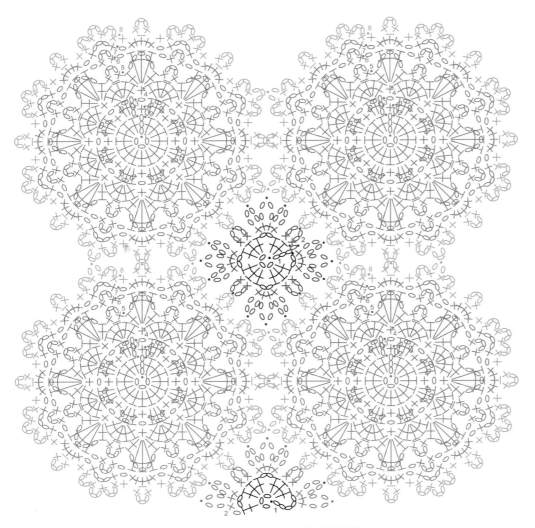

JOINING AND FILLER MOTIF

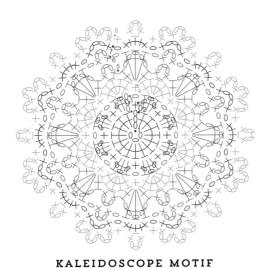

KALEIDOSCOPE MOTIF

strips 2–6

FIRST MOTIF ONLY

Rnd 8: Rep Rnd 8 as for motifs 2–8, joining to side of first strip.

MOTIFS 2–8

Rnd 8: Join C with sc in any ch-3 sp, (ch 3, sc, [ch-3 join, sc] 2 times) in same sp, sc in next ch-1 sp, sk next 2 sc, (sc, ch-3 join, sc) in blo of next sc, sc in next ch-1 sp, ([sc, ch-3 join, sc] 2 times, ch 3, sc) in next ch-3 sp, sc in next ch-1 sp, sk next 2 sc, (sc, ch 3, sc) in blo of next sc, sc in next ch-1 sp, (sc, ch 3, [sc, ch-3 join, sc] 2 times) in next ch-3 sp, sc in next ch-1 sp, sk next 2 sc, (sc, ch-3 join, sc) in blo of next sc, sc in next ch-1 sp, ([sc, ch-3

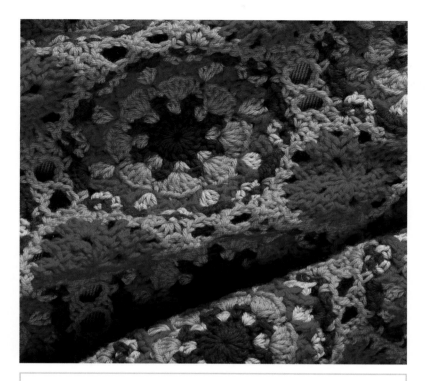

When working stitches behind chains from a previous round, it is easiest to push the chains right down flat to get them out of the way until they are needed again. **—TAMMY HILDEBRAND**

join, sc] 2 times, ch 3, sc) in next ch-3 sp, sc in next ch-1 sp, sk next 2 sc, (sc, ch 3, sc) in blo of next sc, sc in next ch-1 sp, * (sc, [ch 3, sc] 3 times) in next ch-3 sp, sc in next ch-1 sp, sk next 2 sc, (sc, ch 3, sc) in blo of next sc, sc in next ch-1 sp; rep from * around, sl st in first sc to join, fasten off.

FILLER MOTIF

With D, ch 3, sl st in first ch to form ring.

Rnd 1: Ch 3 (counts as dc), 2 dc in ring, ch 2, *3 dc in ring, ch 2; rep from * 3 more times, sl st in top of beg ch-3 to join, 12 dc, 4 ch-2 sps.

Rnd 2: Ch 1, sl st in next st, ch 1, *sc in center st, working in opening bet motifs and joining to chs, ch-5 join (see Stitch Guide) attaching to side of motif, sc in same sc on filler, sc in next ch-2 sp, ch-5 join in next ch on motif, sc in same sp on filler,

ch-5 join in center of motif joining, sc in same sp on filler, ch-5 join in next ch on motif, sc in same sp on filler; rep from * around, sl st in first sc to join, fasten off—24 sc, 16 ch-5 joins.

HALF FILLER MOTIF

With D, ch 3, sl st in first ch to form ring.

Rnd 1: Ch 5 (counts as dc, ch 2), [3 dc in ring, ch 2] 2 times, dc in ring, turn—8 dc, 3 ch-2 sps.

Rnd 2: Ch 1, sc in first st, working around outside of afghan in sp bet motifs, ch-5 join in corner ch-3, sc in ch-2 sp on filler, ch-5 join in next ch-3 on motif, sc in same ch-2 sp on filler, sk next st, (sc, ch-5 join, sc) in next st, sc in next ch-2 sp, ch-5 join in next ch on motif, sc in same sp on filler, ch-5 join in center of motif joining, sc in same sp on filler, ch-5 join in next ch on motif, sc in same sp on filler, sk next st, (sc, ch-5 join, sc) in next st, sc in next ch-2 sp, ch-5 join in next ch on motif, sc in same ch-2 sp, ch-5 join in next ch on motif, sc in 3rd ch of turning ch, fasten off.

BORDER

Rnd 1: With RS facing, join C with sl st in any ch-3 sp on outer edge of afghan, ch 3, (counts as dc), 2 dc in same sp, *sh in each ch-3 sp to next filler, 3 dc in center of joining, sh over post of st at each end of Row 1, 3 dc in center of joining; rep from * around, sl st in top of beg ch-3 to join.

Rnd 2: Ch 1, sc in same sp as join, (sc, ch 3, sc) in center st of next sh, *sc in sp before next sh, (sc, ch 3, sc) in center st of next sh; rep from * around, sl st in first sc to join, fasten off.

finishing

Weave in loose ends. Spread afghan flat on soft surface such as folded blankets or a bare mattress. Using spray bottle, mist entire afghan. Place pins around edges to hold in place. Allow to dry completely before removing pins.

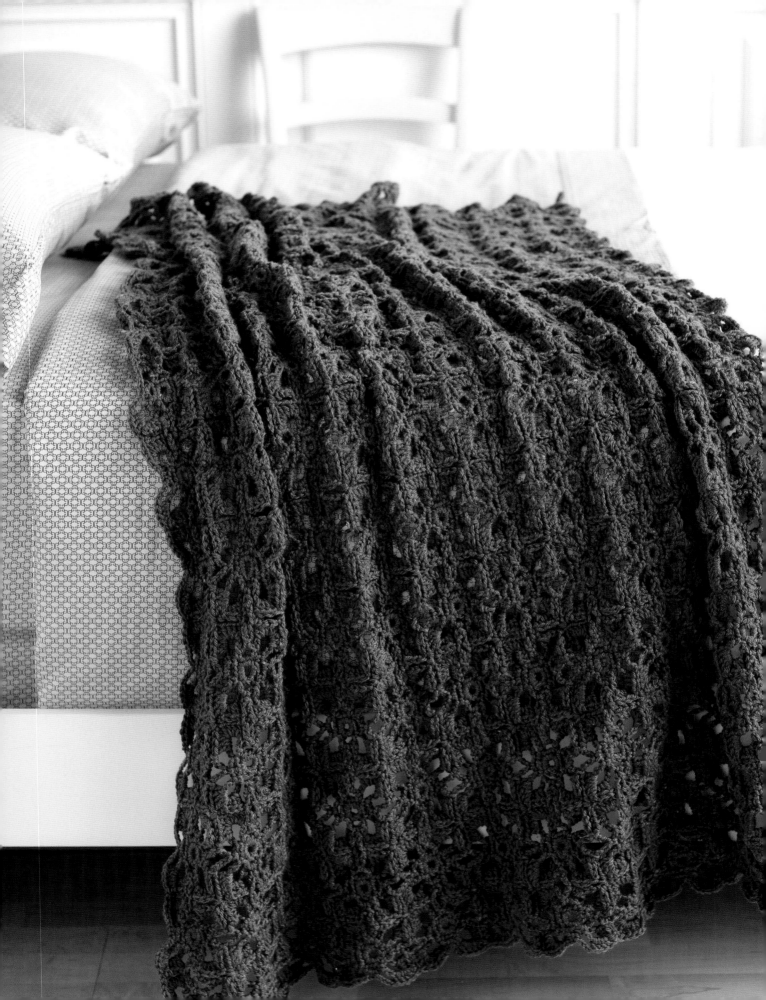

MOROCCAN TILE
afghan

DESIGNED BY **KRISTIN OMDAHL**

The geometric detailing of Moroccan tile-work inspires many of designer Kristin Omdahl's motifs, including the one used in this blanket. The center of the motif is quite simple, and the spade-shaped corners line up beautifully with the adjacent motifs to suggest a different motif altogether. As an added bonus, the blanket requires no edging because the motifs naturally display a pretty scalloped detail.

FINISHED SIZE
39" wide x 52" long (99 x 132 cm).

YARN
Worsted weight (#4 Medium).

SHOWN HERE: Red Heart Eco-Ways (70% acrylic/30% recycled polyester; 186 yd [170 m]/ 4 oz [113 g]): #3518 peacock, 8 balls.

HOOK
I/9 (5.5 mm) or size needed to obtain gauge.

NOTIONS
Tapestry needle for weaving in ends.

GAUGE
1 motif = 3¼" (8.5 cm) square after blocking.

moroccan tile motif

Refer to Stitch Diagram A for assistance.

MOTIF 1A

Rnd 1: Ch 5 + 1 + 1 + 5 + 3 = 15, sl st in 5th ch from hook to form ring. Sl st in next ch (counts as sc), 11 sc in ring—2 sc.

Rnd 2: Sl st in next ch (counts as sc), *ch 3, sk next 2 sts, (sc, ch 9, sc) in next st. Rep from * twice. Ch 3, sk next 2 sts, sc in next st, ch 4, sl st in 5th ch of beg ch (counts as ch-9 loop).

Rnd 3: Sl st in ea of next 3 ch (counts as dc), 3 dc in same ch-9 sp, ch 4, sc in next ch-3 sp, ch 4, (4 dc, ch 1, 4 dc) in next ch-9 sp. Ch 4, sc in next ch-3 sp, ch 4, 4 dc in next ch-9 sp.

MOTIF 1B

Rnds 1–2: Rep Rnds 1–2 of Motif 1A.

Rnd 3: Sl st in ea of next 3 ch (counts as dc), 3 dc in same ch-9 sp, sl st in ch-4 sp on adjacent motif, *ch 4, sc in next ch-3 sp, ch 4, sl st in next ch-4 sp on adjacent motif, (4 dc, sl st in ch-1 sp on adjacent motif, 4 dc) in next ch-9 sp. Ch 4, sc in next ch-3 sp, ch 4, (4 dc, ch 1, 4 dc) in next ch-9 sp. Ch 4, sc in next ch-3 sp, ch 4, 4 dc in next ch-9 sp.

MOTIF 1C

Rnds 1–2: Rep Rnds 1–2 of Motif 1A.

Rnd 3: Sl st in ea of next 3 ch (counts as dc), 3 dc in same ch-9 sp, sl st in ch-4 sp on adjacent motif, *ch 4, sc in next ch-3 sp, ch 4, sl st in next ch-4 sp on adjacent motif, (4 dc, sl st in ch-1 sp on adjacent motif, 4 dc) in next ch-9 sp. *Ch 4, sc in next ch-3 sp, ch 4, (4 dc, ch 1, 4 dc) in next ch-9 sp. Rep from * once. Ch 4, sc in next ch-3 sp, ch 4, 4 dc in last ch-9 sp.

Working across incomplete motifs in row 1, *sl st in sp before next motif, 4 dc in next ch-9 sp, ch 4, sc in next ch-3 sp, ch 4, 4 dc in next ch-9 sp. Rep from * once.

MOTIF 2A

Rnds 1–2: Rep Rnds 1–2 of Motif 1A.

Rnd 3: Sl st in ea of next 3 ch (counts as dc), 3 dc in same ch-9 sp, sl st in ch-4 sp on adjacent motif (Motif 1A), ch 4, sc in next ch-3 sp, ch 4, sl st in next ch-4 sp on adjacent motif (Motif 1A), (4 dc, sl st in junction on adjacent

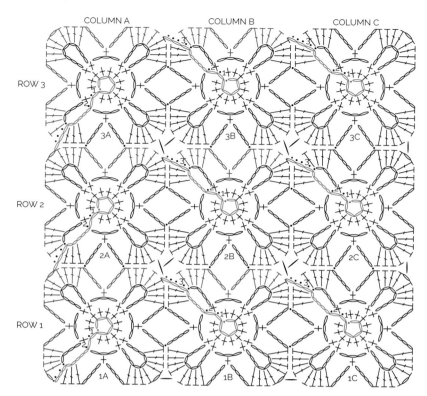

STITCH DIAGRAM A

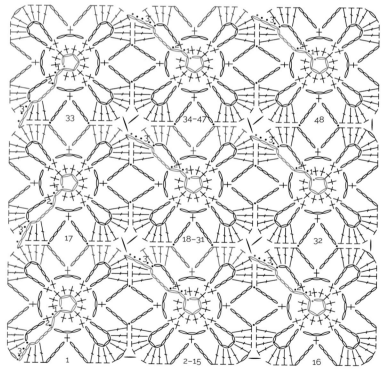

STITCH DIAGRAM B

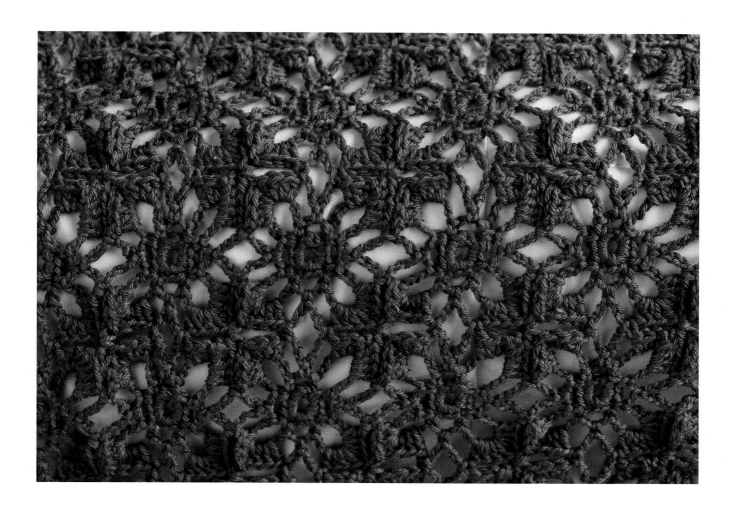

motif, 4 dc) in next ch-9 sp. Ch 4, sc in next ch-3 sp, ch 4, 4 dc in next ch-9 sp.

MOTIF 2B

Rnds 1–2: Rep Rnds 1–2 of Motif 1A.

Rnd 3: Sl st in ea of next 3 ch (counts as dc), 3 dc in same ch-9 sp, sl st in ch-4 sp on adjacent motif (Motif 2A), ch 4, sc in next ch-3 sp, ch 4, sl st in next ch-4 sp on adjacent motif (Motif 2A), (4 dc, sl st in junction on adjacent motif, 4 dc) in next ch-9 sp. Sl st in ch-4 sp on adjacent motif (Motif 1B), ch 4, sc in next ch-3 sp, ch 4, sl st in next ch-4 sp on adjacent motif (Motif 1B), (4 dc, sl st in junction on adjacent motif, 4 dc) in next ch-9 sp. Ch 4, sc in next ch-3 sp, ch 4, 4 dc in next ch-9 sp.

MOTIF 2C

Rnds 1–2: Rep Rnds 1–2 of Motif 1A.

Rnd 3: Sl st in ea of next 3 ch (counts as dc), 3 dc in same ch-9 sp, sl st in ch-4 sp on adja-

cent motif (Motif 2B), *ch 4, sc in next ch-3 sp, ch 4, sl st in next ch-4 sp on adjacent motif (Motif 2B), (4 dc, sl st in junction on adjacent motif, 4 dc) in next ch-9 sp. Sl st in ch-4 sp on adjacent motif (Motif 1C), ch 4, sc in next ch-3 sp, ch 4, sl st in next ch-4 sp on adjacent motif (Motif 1C), (4 dc, sl st in ch-1 on adjacent motif, 4 dc) in next ch-9 sp, ch 4, sc in next ch-3 sp, ch 4, (4 dc, ch 1, 4 dc) in next ch-9 sp, ch 4, sc in next ch-3 sp, ch 4, 4 dc in next ch-9 sp.

Working across incomplete motifs in row 2, *sl st in sp before next motif, 4 dc in next ch-9 sp, ch 4, sc in next ch-3 sp, ch 4, 4 dc in next ch-9 sp. Rep from * once.

MOTIF 3A

Rep Motif 2A.

MOTIF 3B

Rep Motif 2B.

MOTIF 3C

Rep Motif 2C.

Working across incomplete motifs in row 3, sl st in sp before next motif, 4 dc in next ch-9 sp, ch 4, sc in next ch-3 sp, ch 4, 4 dc in next ch-9 sp. Sl st in sp before next motif, 4 dc in next ch-9 sp, ch 4, sc in next ch-3 sp, ch 4, (4 dc, ch 1, 4 dc) in next ch-9 sp, ch 4, sc in next ch-3 sp, ch 4, 4 dc in next ch-9 sp.

Working across side edge of incomplete motifs in column A, sl st in sp before next motif, 4 dc in next ch-9 sp, ch 4, sc in next ch-3 sp, ch 4, 4 dc in next ch-9 sp. Sl st in next sp before next motif, 4 dc in next ch-9 sp, ch 4, sc in next ch-3 sp, ch 4, 4 dc in next ch-9 sp, sl st to first ch at beg of Motif 1A to join. Fasten off.

moroccan tile blanket

Refer to the instructions for the Moroccan Tile Motif on page 14 for motifs referenced in these instructions; refer to Stitch Diagram B (page 14) for assistance.

MOTIF 1

Work same as Motif 1A.

MOTIFS 2–15

Work same as Motif 1B.

MOTIF 16

Work same as Motif 1C.

Working across incomplete Motifs 15–1, *sl st in sp before next motif, 4 dc in next ch-9 sp, ch 4, sc in next ch-3 sp, ch 4, 4 dc in next ch-9 sp. Rep from * 14 times.

MOTIF 17

Work same as Motif 2A.

MOTIF 18–31

Work same as Motif 2B.

MOTIF 32

Work same as Motif 2C.

Working across incomplete Motifs 31–17, *sl st in sp before next motif, 4 dc in next ch-9 sp, ch 4, sc in next ch-3 sp, ch 4, 4 dc in next ch-9 sp. Rep from * 14 times.

MOTIFS 33–192

Rep Motifs 17–32 ten times.

Working across incomplete Motifs 191–177, *sl st in sp before next motif, 4 dc in next ch-9 sp, ch 4, sc in next ch-3 sp, ch 4, 4 dc in next ch-9 sp. Rep from * 13 times. Sl st in ch-1 sp before next motif, 4 dc in next ch-9 sp, ch 4, sc in next ch-3 sp, ch 4, (4 dc, ch 1, 4 dc) in next ch-9 sp, ch 4, sc in next ch-3 sp, ch 4, 4 dc in next ch-9 sp.

Working along side edge of incomplete Motifs 161, 145, 129, 113, 97, 81, 65, 49, 33, 17, and 1, *sl st in sp before next motif, 4 dc in next ch-9 sp, ch 4, sc in next ch-3 sp, ch 4, 4 dc in next ch-9 sp. Rep from * 9 times. Sl st in sp before next motif, 4 dc in next ch-9 sp, ch 4, sc in next ch-3 sp, ch 4, 4 dc in next ch-9 sp, sl st to first ch at beg of Motif 1. Fasten off. Weave in ends.

Wet-block afghan to finished measurements and let dry.

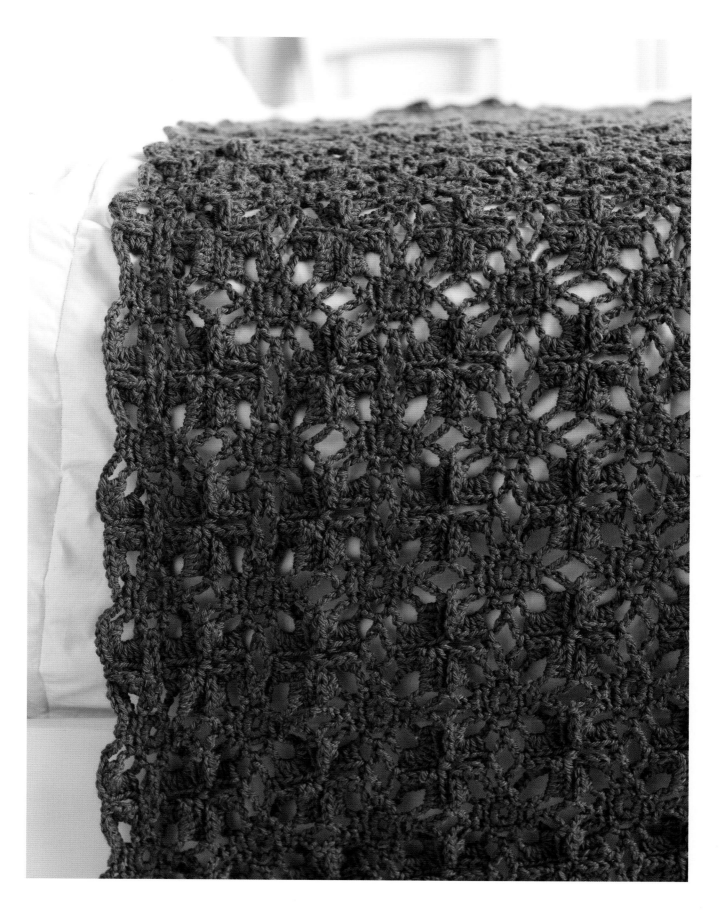

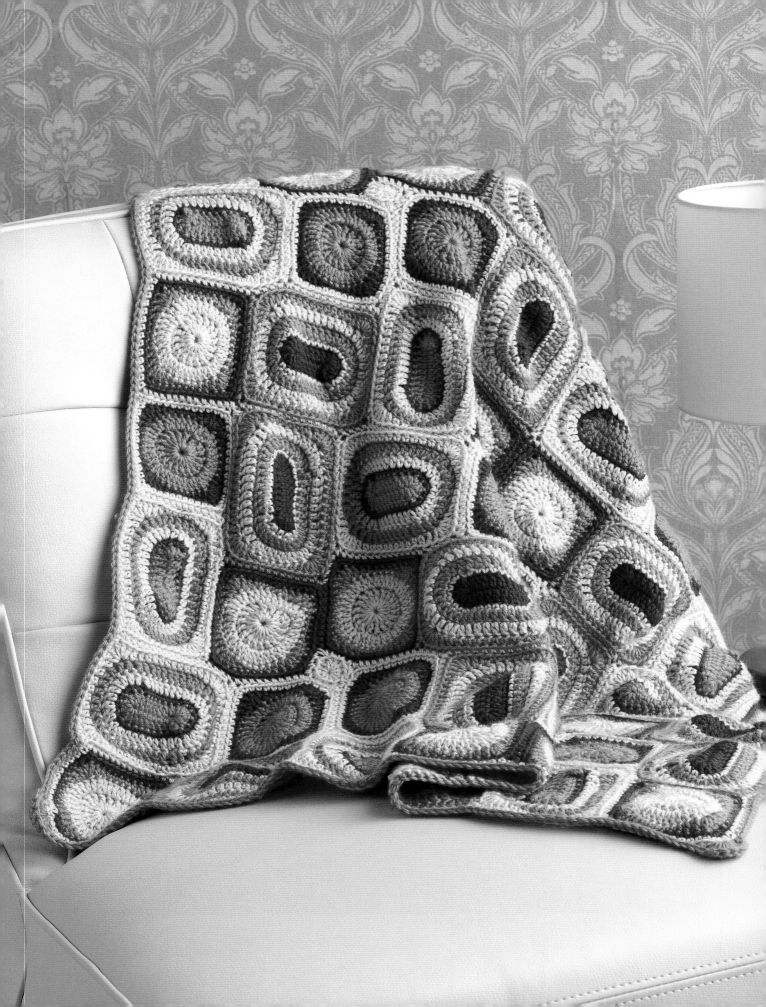

DOTS + DASHES
blanket

DESIGNED BY **ELLEN GORMLEY**

Modular and modern, this baby blanket will be the highlight of a baby's collection. With a quick color change, this project can be customized for a girl, a boy, or even an adult. Because of the building-block style of the motifs, the blanket can easily be made in larger or smaller sizes.

FINISHED SIZE

37" × 37" (94 × 94 cm).

YARN

Worsted weight (#4 Medium).

SHOWN HERE: Caron, Simply Soft (100% acrylic; 315 yd [288 m]/6 oz [170 g]): #9754 persimmon (MC), 2 balls; #9719 soft pink (CC1), 2 balls; #9723 raspberry (CC2), 1 ball.

HOOK

I/9 (6 mm) or hook needed to obtain gauge.

NOTIONS

Tapestry needle for weaving in ends; spray bottle with water and straight pins for blocking.

GAUGE

Square motif = 4" × 4" (10 × 10 cm) in stitch pattern.

Rectangle motif = 4" × 5" (10 cm × 13 cm) in stitch pattern.

NOTE

✦ All rounds are worked on the RS and are joined and not turned.

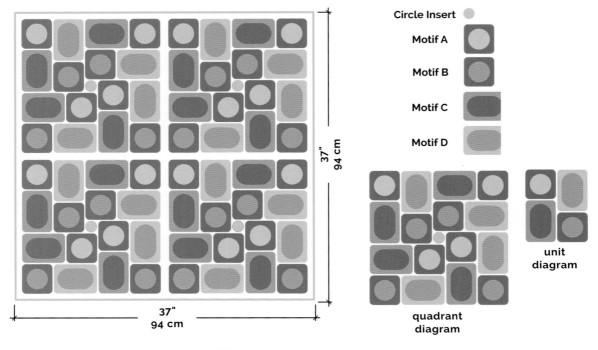

Circle Insert

Motif A

Motif B

Motif C

Motif D

unit diagram

quadrant diagram

CONSTRUCTION DIAGRAM

pattern

SQUARE MOTIF

Refer to **Square Motif Diagram A** (page 22) for assistance.

Make 16 ea of Motifs A and B as follows.

MOTIF A

Rnd 1: CC1.

Rnd 2: CC1.

Rnd 3: MC.

Rnd 4: CC2.

MOTIF B

Rnd 1: MC.

Rnd 2: MC.

Rnd 3: CC2.

Rnd 4: CC1.

With first color, ch 5; join with sl st to form a ring.

Rnd 1: Ch 4 (counts as first tr), 17 more tr in ring; join with sl st in top beg ch-4—18 tr.

Rnd 2: Ch 3 (counts as first dc), dc in same st, 2 dc in ea st around; join with sl st in top beg ch-3—36 dc. Fasten off.

Rnd 3: With RS facing, join next color with sl st in any st, ch 3 (counts as dc), 2 dc in same st; *dc in next st, hdc in next st, sc in next 4 sts, hdc in next st, dc in next st**, 3 dc in next st; rep from * twice; rep from * to ** once; join with sl st in top beg ch-3—20 dc, 8 hdc, 16 sc. Fasten off.

Rnd 4: With RS facing, join next color with sc in middle sc of any sc-3 corner, 2 sc in same st; *sc in ea of next 10 sts, 3 sc in next st; rep from * twice, sc in ea of last 10 sts; join with sl st in first sc—52 sc. Fasten off.

RECTANGLE MOTIF

Refer to **Rectangle Motif Diagram B** (page 22) for assistance.

Make 16 ea of Motifs C and D as follows.

MOTIF C

Rnd 1: CC2.

Rnd 2: CC1.

Rnd 3: MC.

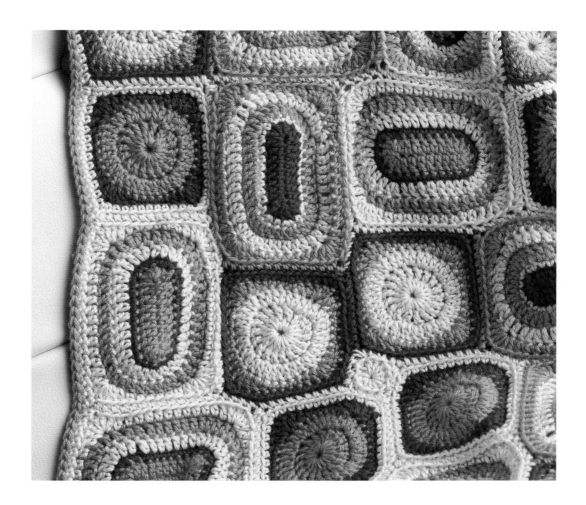

Rnd 4: CC1.

Rnd 5: MC.

MOTIF D

Rnd 1: MC.

Rnd 2: CC2.

Rnd 3: CC1.

Rnd 4: MC.

Rnd 5: CC1.

With first color, ch 12.

Rnd 1: 5 dc in 4th ch from hook, dc in ea of next 7 sts, 6 dc in last ch, working along foundation ch, dc in ea of next 7 sts; join with sl st in 11th ch, which is the top of the first dc. Fasten off—26 dc.

Rnd 2: With RS facing, join next color with sc in first dc of 6-dc end, [2 sc in next st, sc in next st] twice, 2 sc in next st, sc in ea of next 8 sts, [2 sc in next st, sc in next st] twice, 2 sc in next st, sc in ea of last 7 sts; join with sl st in first sc. Fasten off—32 sc.

Rnd 3: With RS facing, join next color with sl st in st where previously fastened off, ch 3 (counts as dc); *[2 dc in next st, dc in next 2 sts] 3 times*, dc in next 7 sts; rep from * to * once, dc in last 6 sts; join with sl st in top of beg ch-3—38 dc. Fasten off.

Rnd 4: With RS facing, join next color with sl st in st where previously fastened off, ch 3 (counts as dc), dc in next 2 sts; *[2 dc in next st, dc in ea of next 3 sts] 3 times*, dc in ea of next 7 sts; rep from * to * once, dc in last 4 sts; join with sl st in top beg ch-3. Fasten off—44 dc.

Rnd 5: With RS facing, join next color with sl st where previously fastened off, ch 2 (counts as hdc), *dc in next st, 5 dc in next st, dc in next st, hdc in next st, sc in ea of next 4 sts, hdc in next st, dc in next st, 5 dc in next st, dc

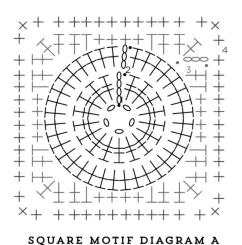

SQUARE MOTIF DIAGRAM A

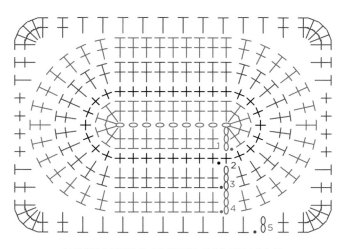

RECTANGLE MOTIF DIAGRAM B

in next st*, hdc in ea of next 10 sts; rep from *
to * once, hdc in ea of last 9 sts; join with sl st
in top beg ch-2. Fasten off—60 sts.

CIRCLE INSERTS (MAKE 4)

With CC1, ch 3; join with sl st in first ch to form
ring.

Rnd 1: Ch 3, (counts as dc), 11 more dc in ring;
join with sl st in beg ch-3—12 dc. Fasten off,
leaving an 18" (45.5 cm) tail for sewing.

ASSEMBLY

Refer to the Construction Diagram on page 20
for assistance. Pin motifs to finished measure-
ments (see gauge on page 19). Spritz with
water and allow to dry.

32 PAIRS OF MOTIFS

With MC and RS facing, working through outer
loops only and matching stitches, sc Motif
A with short side of Motif C. Rep to make 15
more pairs. Rep the same process with Motif B
and the short side of Motif D to make 16 pairs.

16 UNITS OF 4 MOTIFS

With CC1 and RS facing, working through
outer lps only and matching sts, sc the A/C
pair to the B/D pair. Rep for the rem 15 units.

> I absolutely love making motif blankets from
> scraps I have in my yarn stash. I even gather
> various swatches I've made and join them
> to create a freeform blanket, then I use a
> great neutral color, such as gray or chocolate
> brown, to bring a unifying effect to the
> blanket. —ELLEN GORMLEY

4 QUADRANTS

The 4 quadrants of the blanket are identical.
Each quadrant uses 4 of the Units. Working
clockwise from top left, the first unit is
vertical, the next unit to the right is horizontal,
the next unit below right is vertical, and the
last unit at bottom left is horizontal. With CC1
and RS facing, working through outer loops
only and matching sts, working from the
outer edge toward the middle empty space
where the CC1 circle insert will go, sc 2 Units
together. Rep 3 more times until the quadrant
is completed. Rep entire process 3 more
times until all 4 quadrants are completed. In
same manner, sc the quadrants together.

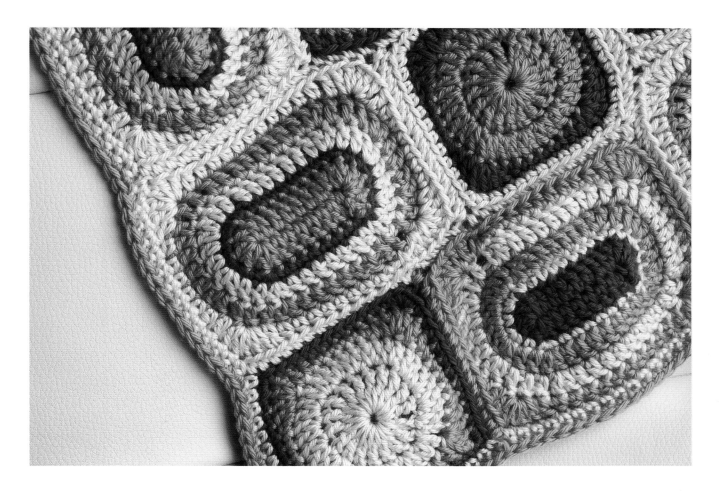

ATTACH CIRCLE INSERTS

With CC1 and tapestry needle and WS facing, hold the insert in the empty space left by the Units, using the long tail, whipstitch the insert into the empty space by whipstitching it to its adjacent neighbors. There are 12 insert stitches and 4 neighboring motifs, ea motif will attach to the insert in 3 of the insert's stitches.

edging and finishing

Rnd 1: With RS facing, join CC1 with sc in middle sc st of any corner, 2 more sc in same st; *sc in ea st to next corner, 3 sc in middle st of next corner; rep from * twice, sc in ea st to end; join with sl st in first sc—516 sc. Fasten off.

Rnd 2: With RS facing, join MC with sl st in middle sc of any corner, ch 4 (counts as first tr), 8 more tr in same st; *sk next 3 sts, sc in ea st across to last 4 sts of side, sk next 3 sts, 9 tr in middle sc of 3-sc corner; rep from * twice, sc in ea st across to last 3 sts, sk next 3 sts; join with sl st in top beg ch-4—488 sc, 36 tr. Fasten off.

Weave in ends.

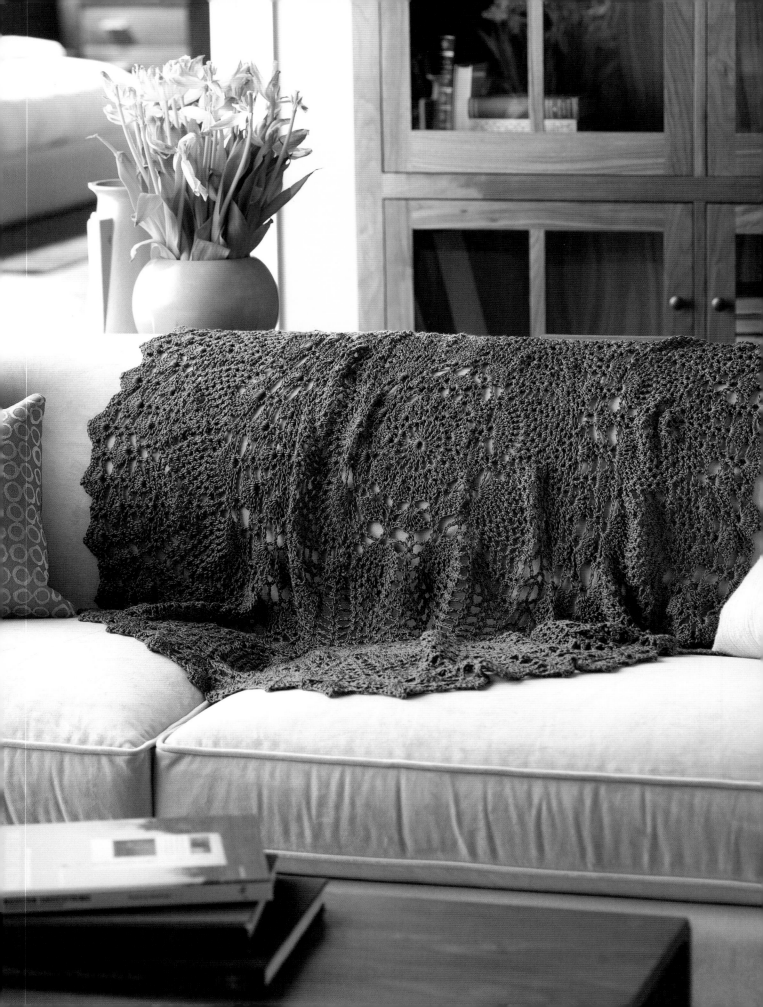

EXPLODED PINEAPPLE
afghan

DESIGNED BY **DORIS CHAN**

In American Colonial times, pineapples were so exotic, costly, and hard to get that they became a fashionable luxury. Later, as a decorative motif in wood carvings and needlework, they became a symbol of welcome and hospitality. In this design, the iconic crocheted pineapple assumes another aspect, one of breezy, exploded gauge, afghan style. It also makes a sweet lightweight shawl.

FINISHED SIZE

50" (127 cm) in diameter before blocking. 52" (132 cm) in diameter blocked.

YARN

Sportweight (#3 Light).

SHOWN HERE: Naturally Caron .com Spa (75% microfiber acrylic, 25% rayon from bamboo; 251 yd [230 m]/3 oz [85 g]): #0010 stormy blue, 5 balls.

HOOK

H/8 (5 mm) or size needed to obtain gauge.

NOTIONS

Tapestry needle for weaving in ends.

GAUGE

Rnds 1–2 = 4" (10 cm) in diameter; Rnds 1–4 = 6½" (16.5 cm) as crocheted before blocking.

NOTES

✦ Afghan is crocheted from the center outward in joined rounds, with RS of stitches always facing as in traditional doily crochet (do not turn after each round).

✦ Each round is different. Please check your work frequently, especially during the outer rounds that are quite long.

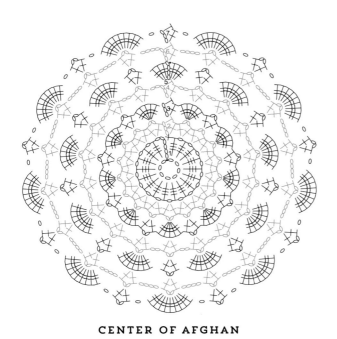

CENTER OF AFGHAN

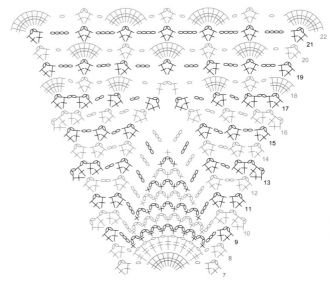

SEGMENT OF LOWER PINEAPPLE

pattern

Ch 8, sl st in first ch to form a ring.

Rnd 1: Ch 6 (counts as dtr, ch 1), [dtr in ring, ch 1] 17 times, sc in 5th ch of beg ch-6 for last ch-sp and join—18 dtr, 18 ch-1 sps.

Rnd 2: Ch 3 (counts as dc), [sk next dtr, V-st (see Stitch Guide) in next ch-1 sp] 17 times, dc in same sp as beg, hdc in 3rd ch of beg ch-3 to complete last V-st and join—18 V-sts.

Rnd 3: Ch 3, [5 tr for sh in ch-2 sp of next V-st, V-st in ch-2 sp of next V-st] 8 times, 5 tr in ch-2 sp of next V-st, dc in same sp as beg, hdc in 3rd ch of beg ch-3 to join—9 sh, 9 V-sts.

Rnd 4: Ch 5 (counts as dc, ch 2), [V-st in 3rd tr at center of next sh, ch 2, V-st in ch-2 sp of next V-st, ch 2] 8 times, V-st in 3rd tr at center of next sh, ch 2, dc in same sp as beg, hdc in 3rd ch of beg ch-5 to join—18 V-sts.

Rnd 5: Ch 4 (counts as tr), 3 tr in beg sp, [V-st in ch-2 sp of next V-st, 7 tr for sh in ch-2 sp of next V-st] 8 times, V-st in ch-2 sp of next V-st, 3 tr in same sp as beg, sl st in 4th ch of beg ch-4 to join.

To encourage the picot to stay on top of a particular st, after completing a tr as indicated, ch 4, then moving hook forward from the ch just made, insert hook from top to bottom in front lp of tr just made AND in one forward strand of the stem of the tr (just below the top lp), going under 2 strands, yo and draw a lp through the tr and through the lp on hook to sl st closed. In other words, insert the hook so that it back-traces the last step of making the tr, back through the stitch.

—DORIS CHAN

Rnd 6: Ch 7 (counts as dc, ch 4), [V-st in ch-2 sp of next V-st, ch 4, V-st in 4th tr at center of next sh, ch 4] 8 times, V-st in ch-2 sp of next V-st, dc in same tr as beg, hdc in 3rd ch of beg ch-7 to join—18 V-sts.

Rnd 7: Ch 4 (counts as dc, ch 1), [9 tr for pineapple base in ch-2 sp of next V-st, ch 1, V-st in ch-2 sp of next V-st, ch 1] 9 times, omitting last (V-st, ch 1), end with dc in same sp as beg, hdc in 3rd ch of beg ch-4 to join—9 pineapple bases.

Rnd 8: Ch 4, *[tr in next tr, ch 1] 9 times, V-st in ch-2 sp of next V-st, ch 1; rep from * 8 more times, omitting last (V-st, ch 1), end with dc in same sp as beg, hdc in 3rd ch of beg ch-4 to join.

Rnd 9: Ch 6 (counts as dc, ch 3), *[sk next tr, sc in next ch-1 sp, ch 3] 8 times, V-st in ch-2 sp of next V-st, ch 3; rep from * 8 more times, omitting last (V-st, ch 3), end with dc in same sp as beg, hdc in 3rd ch of beg ch-6 to join.

Rnd 10: Ch 5, dc in beg sp for V-st, *[ch 3, sk next sc, sc in next ch-3 sp] 7 times, ch 3, (V-st, ch 2, V-st) in ch-2 sp of next V-st; rep from * 8 more times, omitting last (V-st, ch 2, V-st), end with V-st in same sp as beg, hdc in 3rd ch of beg ch-5 to join.

Rnd 11: Ch 3, *V-st in ch-2 sp of next V-st, [ch 3, sk next sc, sc in next ch-3 sp] 6 times, ch 3, V-st in ch-2 sp of next V-st, V-st in next ch-2 sp (bet V-sts); rep from * 8 more times, omitting last V-st, end with dc in same sp as beg, hdc in 3rd ch of beg ch-3 to join.

Rnd 12: Ch 5, *V-st in ch-2 sp of next V-st, [ch 3, sk next sc, sc in next ch-3 sp] 5 times, ch 3, [V-st in ch-2 sp of next V-st, ch 2] 2 times; rep from * 8 more times, omitting last (V-st, ch 2), end with dc in same sp as beg, hdc in 3rd ch of beg ch-5 to join.

Rnd 13: Ch 5, dc in beg sp for V-st, *ch 2, V-st in ch-2 sp of next V-st, [ch 3, sk next sc, sc in next ch-3 sp] 4 times, ch 3, V-st in ch-2 sp of next V-st, ch 2**, (V-st, ch 2, V-st) in ch-2 sp of next V-st*; rep from * to * 7 more times; rep from * to ** once, end with V-st in same sp as beg, hdc in 3rd ch of beg ch-5 to join.

Rnd 14: Ch 3, *V-st in ch-2 sp of next V-st, ch 2, V-st in ch-2 sp of next V-st, [ch 3, sk next sc, sc in next ch-3 sp] 3 times, ch 3, V-st in ch-2 sp of next V-st, ch 2, V-st in ch-2 sp of next V-st, V-st in next ch-2 sp (bet V-sts); rep from * 8 more times, omitting last V-st, end with dc in same sp as beg, hdc in 3rd ch of beg ch-3 to join.

Rnd 15: Ch 5, *V-st in ch-2 sp of next V-st, ch 2, V-st in ch-2 sp of next V-st, [ch 3, sk next sc, sc in next ch-3 sp] 2 times, ch 3, [V-st in ch-2 sp of next V-st, ch 2] 3 times; rep from * 8 more times, omitting last (V-st, ch 2), end with dc in same sp as beg, hdc in 3rd ch of beg ch-5 to join.

Rnd 16: Ch 5, dc in beg sp, *[ch 2, V-st in ch-2 sp of next V-st] 2 times, ch 3, sk next sc, sc in next ch-3 sp, ch 3, [V-st in ch-2 sp of next V-st, ch 2] 2 times**, (V-st, ch 2, V-st) in ch-2 sp of next V-st*; rep from * to * 7 more times, rep from * to ** once, end with V-st in same sp as beg, hdc in 3rd ch of beg ch-5 to join.

Rnd 17: Ch 5, *[V-st in ch-2 sp of next V-st, ch 2] 2 times, V-st in ch-2 sp of next V-st, sk next 2 ch-3 sps (do not ch as you sk pineapple point), [V-st in ch-2 sp of next V-st, ch 2] 3 times, V-st in next ch-2 sp (bet V-sts), ch 2; rep from * 8 more times, omitting last (V-st, ch 2), end with dc in same sp as beg, hdc in 3rd ch of beg ch-5 to join.

Rnd 18: Ch 4, 2 tr in beg sp, *ch 1, V-st in ch-2 sp of next V-st, ch 1, 5 tr for sh in ch-2 sp of next V-st, ch 1, (dc in ch-2 sp of next V-st, ch 2, dc in ch-2 sp of next V-st) across pineapple point (counts as V-st), ch 1, 5 tr in ch-2 sp of next V-st, ch 1, V-st in ch-2 sp of next V-st, ch 1, 5 tr in ch-2 sp of next V-st; rep from * 8 more times, omitting last 5 tr, end with 2 tr in same sp as beg, sl st in 4th ch of beg ch-4 to join—27 sh.

Rnd 19: Ch 6, [V-st in ch-2 sp of next V-st, ch 3, V-st in 3rd tr at center of next sh, ch 3] 27 times, omitting last (V-st, ch 3), end with dc in same st as beg, hdc in 3rd ch of beg ch-6 to join—54 V-sts.

Rnd 20: Ch 4 (counts as dc, ch 1), [7 tr for sh in ch-2 sp of next V-st, ch 1, V-st in ch-2 sp of next V-st, ch 1] 27 times, omitting last (V-st, ch 1), end with dc in same sp as beg, hdc in 3rd ch of beg ch-4 to join—27 sh.

Rnd 21: Ch 7 (counts as dc, ch 4), [V-st in 4th tr at center of next sh, ch 4, V-st in ch-2 sp of next V-st, ch 4] 27 times, omitting last (V-st, ch 4), end with dc in same sp as beg, ch 2, sl st in 3rd ch of beg ch-7, fasten off and cut yarn—54 V-sts.

Shift the joining of rnds, as foll: sk beg V-st, join new yarn with sl st in ch-2 sp of next V-st (or in any V-st worked into the center of a sh). Be careful, as the V-sts in the wedges bet the next 27 pineapples do not inc the same way as in previous rounds.

Rnd 22: Ch 4, [9 tr for pineapple base in ch-2 sp of next V-st, ch 1, V-st in ch-2 sp of next V-st, ch 1] 27 times, omitting last (V-st, ch 1), end with dc in same sp as beg, hdc in 3rd ch of beg ch-4 to join—27 pineapple bases.

Rnd 23: Ch 4, *[tr in next tr, ch 1] 9 times, V-st in ch-2 sp of next V-st, ch 1; rep from * 26 more times, omitting last (V-st, ch 1), end with dc in same sp as beg, hdc in 3rd ch of beg ch-4 to join.

Rnd 24: Ch 6 (counts as dc, ch 3), *[sk next tr, sc in next ch-1 sp, ch 3] 8 times, V-st in ch-2 sp of next V-st, ch 3; rep from * 26 more times, omitting last (V-st, ch 3), end with dc in same sp as beg, hdc in 3rd ch of beg ch-6 to join.

Rnd 25: Ch 6, *[sk next sc, sc in next ch-3 sp, ch 3] 7 times, V-st in ch-2 sp of next V-st, ch 3; rep from * 26 more times, omitting last (V-st, ch 3), end with dc in same sp as beg, hdc in 3rd ch of beg ch-6 to join.

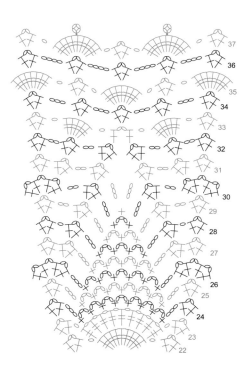

SEGMENT OF UPPER PINEAPPLE

Rnd 26: Ch 5, dc in beg sp for V-st, *[ch 3, sk next sc, sc in next ch-3 sp] 6 times, ch 3, (V-st, ch 2, V-st) in ch-2 sp of next V-st; rep from * 26 more times, omitting last (V-st, ch 2, V-st), end with V-st in same sp as beg, hdc in 3rd ch of beg ch-5 to join.

Rnd 27: Ch 3, *V-st in ch-2 sp of next V-st, [ch 3, sk next sc, sc in next ch-3 sp] 5 times, ch 3, V-st in ch-2 sp of next V-st, V-st in next ch-2 sp (bet V-sts); rep from * 26 more times, omitting last V-st, end with dc in same sp as beg, hdc in 3rd ch of beg ch-3 to join.

Rnd 28: Ch 4, *V-st in ch-2 sp of next V-st, [ch 3, sk next sc, sc in next ch-3 sp] 4 times, ch 3, [V-st in ch-2 sp of next V-st, ch 1] 2 times; rep from * 26 more times, omitting last (V-st, ch 1), end with dc in same sp as beg, hdc in 3rd ch of beg ch-4 to join.

Rnd 29: Ch 5, *V-st in ch-2 sp of next V-st, [ch 3, sk next sc, sc in next ch-3 sp] 3 times, ch 3, [V-st in ch-2 sp of next V-st, ch 2] 2 times; rep from * 26 more times, omitting last (V-st, ch 2), end with dc in same sp as beg, hdc in 3rd ch of beg ch-5 to join.

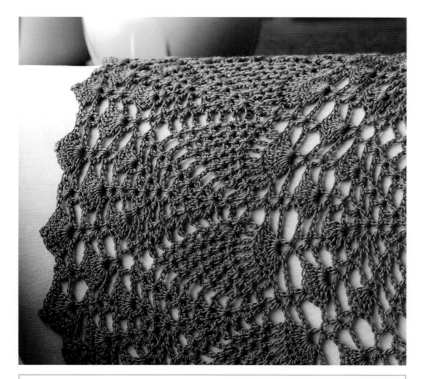

An exploded-gauge doily such as this afghan, made from the center out in rounds where you are always looking at the right side of the stitches, presents one big problem—a really, really big problem. The outer rounds are huge. If you come upon a mistake in the round below and want to go back and fix it, that means ripping back the entire circumference of the afghan. Been there, done that more times than I want to talk about. So please check your work carefully and often. The best way to keep up with it is to glance back each time you complete a bite—for example, a pineapple repeat.

—DORIS CHAN

Rnd 30: Ch 5, dc in beg sp for V-st, *ch 2, V-st in ch-2 sp of next V-st, [ch 3, sk next sc, sc in next ch-3 sp] 2 times, ch 3, V-st in ch-2 sp of next V-st, ch 2**, (V-st, ch 2, V-st) in ch-2 sp of next V-st*; rep from * to * 25 times; rep from * to ** once, end with V-st in same sp as beg, hdc in 3rd ch of beg ch-5 to join.

Rnd 31: Ch 3, *V-st in ch-2 sp of next V-st, ch 2, V-st in ch-2 sp of next V-st, ch 3, sk next sc, sc in next ch-3 sp, ch 3, V-st in ch-2 sp of next V-st, ch 2, V-st in ch-2 sp of next V-st, V-st in next ch-2 sp (bet V-sts); rep from * 26 more times, omitting last V-st, end with dc in same sp as beg, hdc in 3rd ch of beg ch-3 to join.

Rnd 32: Ch 5, *V-st in ch-2 sp of next V-st, ch 2, V-st in ch-2 sp of next V-st, sk next 2 ch-3 sps (do not ch as you sk pineapple point), [V-st in ch-2 sp of next V-st, ch 2] 3 times; rep from * 26 more times, omitting last (V-st, ch 2), end with dc in same sp as beg, hdc in 3rd ch of beg ch-5 to join.

Rnd 33: Ch 4, *5 tr for sh in ch-2 sp of next V-st, ch 1, (dc in ch-2 sp of next V-st, ch 2, dc in ch-2 sp of next V-st) across pineapple point (counts as V-st), ch 1, 5 tr in ch-2 sp of next V-st, ch 1, V-st in ch-2 sp of next V-st, ch 1; rep from * 26 more times, omitting last 5 tr, end with 2 tr in same sp as beg, sl st in 4th ch of beg ch-4 to join—54 sh.

Rnd 34: Ch 6, [V-st in 3rd tr at center of next sh, ch 3, V-st in ch-2 sp of next V-st, ch 3] 54 times, omitting last (V-st, ch 3), end with dc in same st as beg, hdc in 3rd ch of beg ch-6 to join—108 V-sts.

Rnd 35: Ch 4, 3 tr in beg sp, [ch 1, V-st in ch-2 sp of next V-st, ch 1, 7 tr for sh in ch-2 sp of next V-st] 54 times, omitting last 7 tr, end with 3 tr in same sp as beg, sl st in 4th ch of beg ch-4 to join—54 sh.

Rnd 36: Ch 7 (counts as dc, ch 4), [V-st in ch-2 sp of next V-st, ch 4, V-st in 4th tr at center of next sh, ch 4] 54 times, omitting last (V-st, ch 4), end with dc in same sp as beg, hdc in 3rd ch of beg ch-7 to join—108 V-sts.

Rnd 37: Ch 4, [(5 tr, picot, 4 tr) in ch-2 sp of next V-st, ch 1, V-st in ch-2 sp of next V-st, ch 1] 54 times, omitting last (V-st, ch 1), end with dc in same sp as beg, ch 2, sl st in 3rd ch of beg ch-4 to join, fasten off.

finishing

Weave in loose ends. Wet-block afghan by submerging project in cold water and gently rolling out the excess water in towels. Lay afghan down and pin to a 52" (132 cm) diameter, smoothing out the slight ruffling that occurs in outer rounds. Allow to dry.

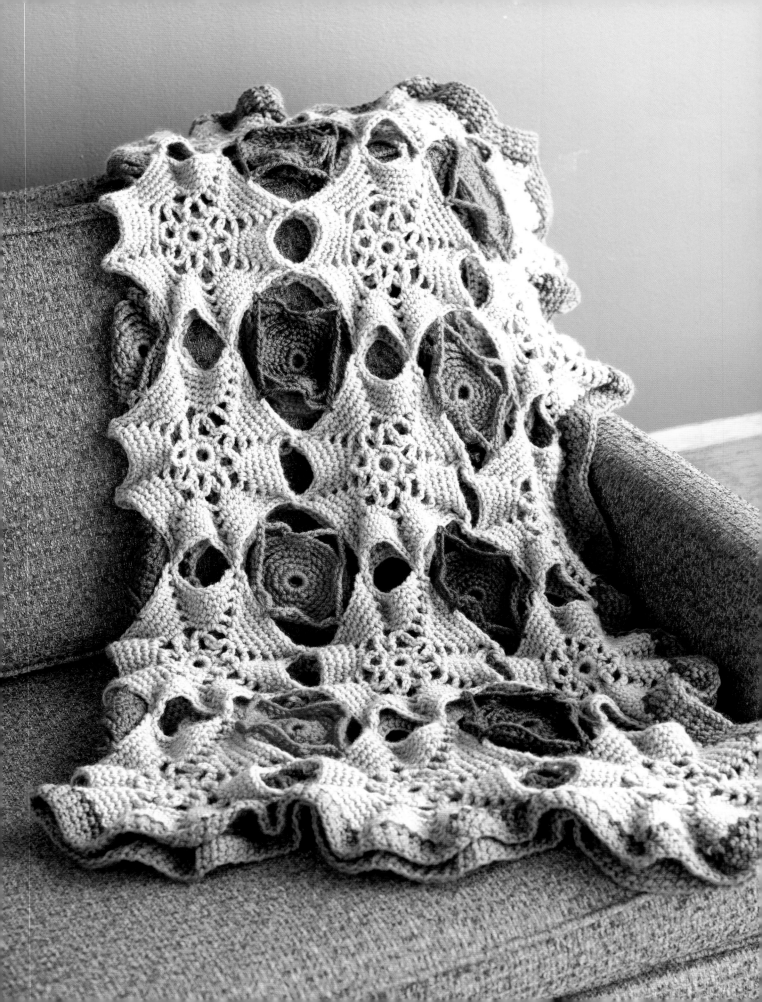

URCHINS + LIMPETS
blanket

DESIGNED BY **KATHY MERRICK**

The background motifs of this blanket are inspired by sea urchins and the cheery centers by limpet shells. Any other combination of neutral background and pops of color would work well. Or change the feeling altogether and use a deep burnt orange as the background and stone gray, charcoal, bottle green, and navy for contrast.

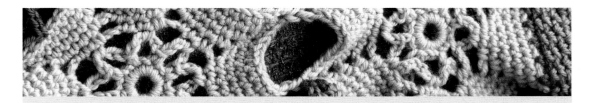

FINISHED SIZE
48" (122 cm) long x 36" (91.5 cm) wide, including border.

YARN
Worsted weight (#4 Medium) in light gray, medium green, orange, muted yellow, muted violet, dark green, dark gray-brown, muted blue, and rust-brown.

SHOWN HERE: Mission Falls 1824 Wool (100% superwash merino wool; 85 yd [78 m]/1 3/4 oz [50 g]): #006 oatmeal (MC), 12 balls; #028 pistachio (C), 2 balls; #026 zinnia (A); # 014 dijon (B); #025 mallow (D); #018 spruce (E); #008 earth (F); #020 cornflower (G); #012 raisin (H), 1 ball each.

HOOK
J/10 (6 mm) or size needed to obtain gauge.

NOTIONS
Tapestry needle.

GAUGE
Each background motif measures 7¾" (19.5 cm) square.

Each center motif measures 3½" (9 cm) square.

NOTES
✦ Motifs are worked with the right side always facing. Do not turn at the end of each round.

✦ After first motif is completed, all subsequent motifs are worked through Rnd 7 as for First Background Motif, then joined to each other during Rnd 8, connecting two chain spaces for each side.

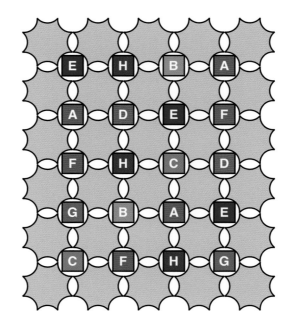

CONSTRUCTION DIAGRAM

blanket

Refer to the Construction Diagram above for assistance.

FIRST BACKGROUND MOTIF

With MC, make an adjustable ring (see Glossary).

Rnd 1: Ch 1, 16 sc into loop, sl st in first sc of rnd—16 sc.

Rnd 2: Ch 1, *sc, ch 5, skip 1 sc; rep from * around, ending with sl st in first sc of rnd—8 ch-sps.

Rnd 3: Sl st twice into first ch-sp, sc in same ch-sp, ch 4, *sc into next ch-sp, ch 4; rep from * around, ending with sc in first sc of rnd.

Rnd 4: Ch 1, sc into side of last sc of prev rnd, sc in next sc, *(sc, ch 4, sc) into next ch-sp, sc in next sc; rep from * around ending with sc in last ch-sp, ch 3, sc into side of first sc—3 sc in each section.

Rnd 5: Ch 1, sc into side of last sc of prev rnd, sc in each sc to ch-sp, *(sc, ch 4, sc) into next ch-sp, sc in each sc to ch-sp; rep from * around ending with sc in last ch-sp, ch 3, sc into side of first sc—5 sc in each section.

Rnds 6–8: Work as for Rnd 5, inc 2 sc in each section, until there are 11 sc in each section. Fasten off.

MOTIFS 2–30

Following the stitch diagram at right, make and join each motif across a row in turn, following First Background Motif through Rnd 7, then joining one or two sides as follows:

JOINING ONE SIDE

Rnd 8: Ch 1, sc into side of last sc of prev rnd, sc in each sc to ch-sp, *(sc, ch 2, sl st in ch-sp of prev motif, ch 2, sc) into next ch-sp, sc in each sc to ch-sp; rep from * once, cont rnd as for First Background Motif—11 sc in each section.

JOINING TWO SIDES

Rnd 8: Ch 1, sc into side of last sc of prev rnd, sc in each sc to ch-sp, *(sc, ch 2, sl st in ch-sp of prev motif, ch 2, sc) into next ch-sp, sc in each sc to ch-sp; rep from * once, rep from * for second adjoining motif twice, cont rnd as for First Background Motif—11 sc in each section.

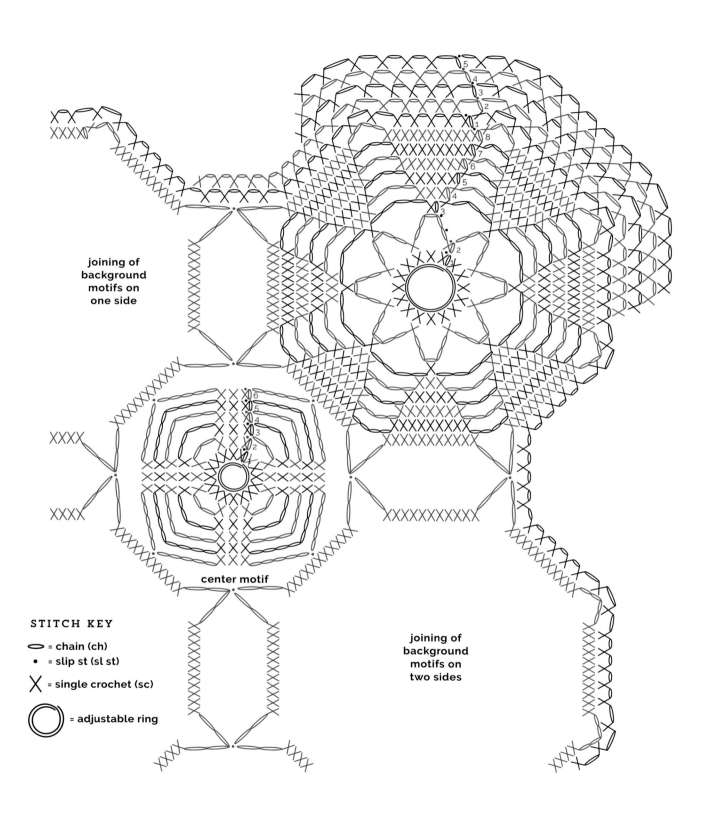

joining of
background
motifs on
one side

joining of
background
motifs on
two sides

center motif

STITCH KEY

⬭ = chain (ch)

• = slip st (sl st)

✕ = single crochet (sc)

◎ = adjustable ring

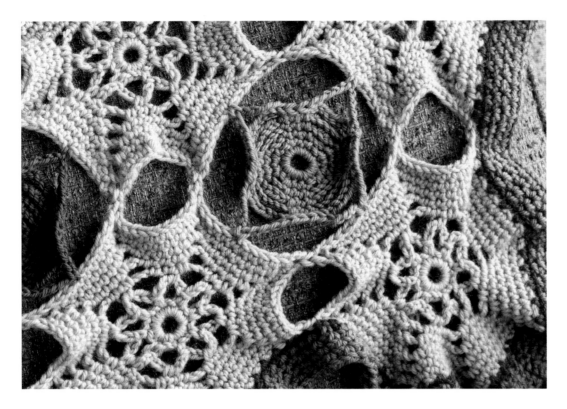

FIRST CENTER MOTIF

With E, make an adjustable ring.

Rnd 1: Ch 1, 16 sc into loop, sl st in first sc to join—16 sc.

Rnd 2: Ch 1, sc in first 3 sc, ch 2, skip next sc, *sc in next 3 sc, ch 2, skip next sc; rep from * around, sl st in first sc to join—4 ch-2 sps.

Rnd 3: Ch 1, *sc in each sc to next ch-sp, ch 4; rep from * around, sl st in first sc to join—4 ch-4 sps.

Rnds 4–5: Work as for Rnd 3, inc 2 ch in each corner on every rnd ending with 4 ch-8 sps.

Rnd 6 (joining rnd): Ch 1, *sc in each sc to next ch-sp, ch 5, sl st in 6th sc of one side of a background motif, ch 5; rep from * around, attaching each side of First Center Motif to one side of surrounding background motifs.

Following Color Guide at top right, cont making Center Motifs, working in rows, beginning at top right corner of blanket.

BORDER

Join H in ch-sp of upper right background motif, ch 1, for each sc section work as follows: [sc in next sc, ch 1, skip next sc] 5 times, sc in last sc, ch 1, for each ch-sp work as follows: [sc, ch 1] twice, work in patt around blanket, sc in first sc to join.

Rnd 2: With B, ch 2, work (sc into next ch-sp, ch 1) around blanket, sl st in beg ch-2 sp to join.

Rnds 3–5: Rep Rnd 2 using G, D, and then C. Fasten off.

finishing

Weave in ends. Gently handwash blanket in cool water and wet-block to final measurements.

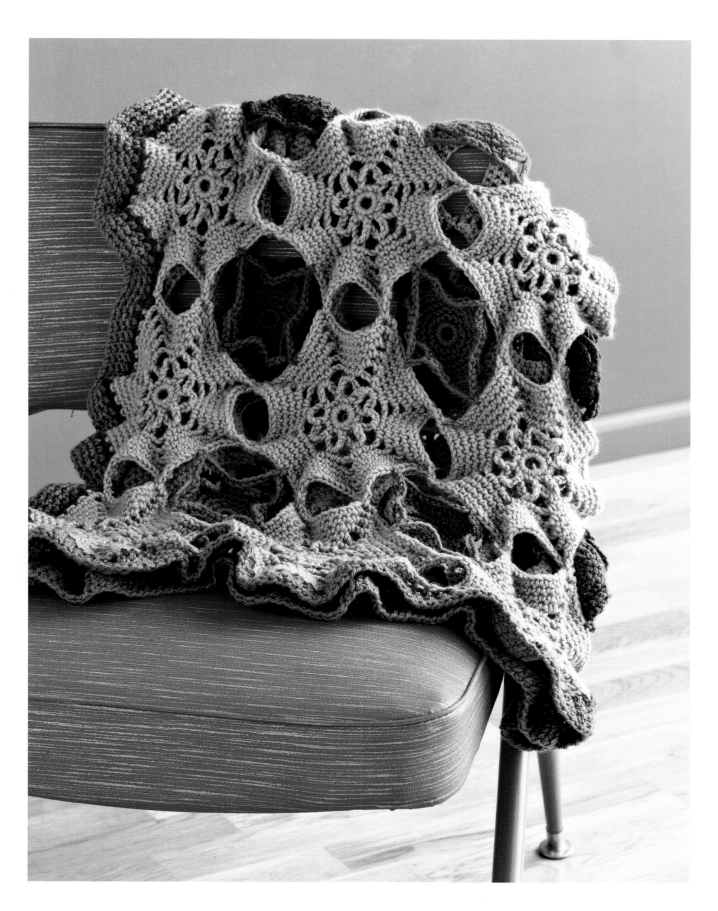

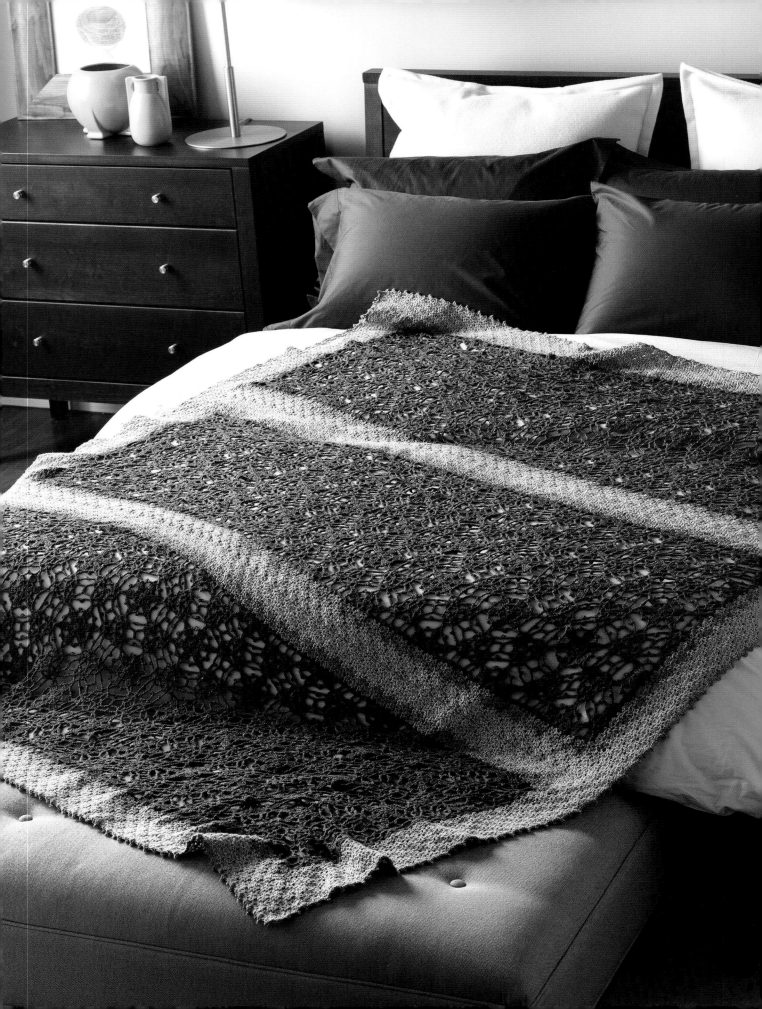

DAMASK
afghan

DESIGNED BY **MARLY BIRD**

Inspired by the beautiful damask drapes in her mother's home, Marly Bird designed this lacy afghan with join-as-you-go motifs coupled with a solid-stitch border, for a little something lacy with a solid edge to it. The yak and bamboo yarn is amazingly soft and a dream to crochet.

FINISHED SIZE
62" x 77" (157.5 x 195.5 cm).

YARN
Sportweight (#2 Fine).

SHOWN HERE: Bijou Basin Ranch Lhasa Wilderness (75% yak, 25% bamboo; 180 yd [165 m]/2 oz [56 g]): #01 natural brown (MC), 14 hanks; #12 sky (CC1), 5 hanks; #13 steel (CC2), 2 hanks.

HOOK
F/5 (3.75 mm) or size needed to obtain gauge.

NOTIONS
Tapestry needle.

GAUGE
Damask Motif = 6½" (16.5 cm) diameter between widest points; 5½" (14 cm) from side to side; 3½" (9 cm) between ch-5 picot and ch-5 picot of outside edge.

NOTE
✦ Join all motifs with RS facing.

border

(MULTIPLE OF 6 + 8 FOUNDATION CHAINS)

Row 1: Sc in second ch from hook, *sk 2 ch, floret (see Stitch Guide) in next ch, sk 2 ch, sc in next ch; rep from * across, turn.

Row 2: Ch 2, dc in first ch-1 of floret, *ch 1, sc in 2nd ch-1 of floret, ch 3, sc in 3rd ch-1 of floret, ch 1**, dc2tog over 4th ch-1 of previous floret and first ch-1 of next floret; rep from * across, ending last rep at **, dc2tog over 4th ch-1 of floret and last sc, turn.

Row 3: Ch 2, [hdc, ch 1, hdc-cl, ch 1] in first st, *sc in next ch-3 sp, floret in next dc2tog; rep from * to last ch-3 sp, half floret (see Stitch Guide) in tch, turn.

Row 4: Ch 1, sc in first st and ch-1, *ch 1, dc2tog over next 2 ch-1 sps, ch-1, sc in next ch-1**, ch 3, sc in next ch-1; rep from * across, ending last rep at **, sc in last st, turn.

Row 5: Ch 1, sc in first st, *floret, sc in next ch-3 sp; rep from * to end, turn.
Rep Rows 2–5 for patt.

motifs

DAMASK MOTIF (MAKE 3, JOIN 81 TO FORM 3 PANELS)

Ch 6, sl st in first ch to form a ring.

Rnd 1 (RS): Ch 3 (counts as dc here and throughout), dc in ring, ch 3, [2 dc in ring, ch 3] 5 times, sl st in 3rd ch of beg ch-3 to join—12 dc and 6 ch-3 sps.

Rnd 2: Ch 3, dc in same ch as join, 2 dc in next dc, ch 1, picot (see Stitch Guide), ch 1, sk next ch-3 sp, [2 dc in each of next 2 dc, ch 1, picot, ch 1, sk next ch-3 sp] 5 times, sl st in 3rd ch of beg ch-3 to join—24 dc and 6 picots.

Rnd 3: Beg x-st (see Stitch Guide), ch 3, picot, ch 3, sk next picot, [x-st (see Stitch Guide) over next 4 dc, ch 3, picot, ch 3, sk next picot] 5 times, sl st in 3rd ch of ch-6 sp on beg x-st to join—6 x-sts and 6 picots.

Rnd 4: Ch 2, (2-dc-cl [see Stitch Guide], ch 3, 3-dc-cl [see Stitch Guide], ch 5, 3-dc-cl, ch 3, 3-dc-cl) in ch-3 sp of beg x-st, ch 3, picot, ch

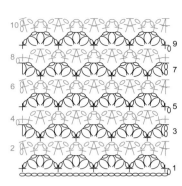

BORDER STITCH PATTERN

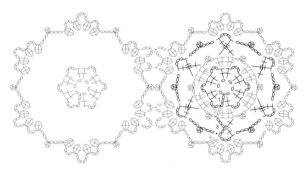

DAMASK MOTIF

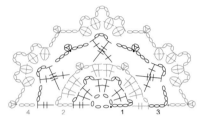

SIDE HALF DAMASK MOTIF

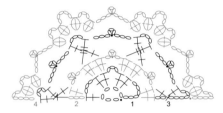

END DAMASK MOTIF

JOINING MOTIFS

3, sk next picot, *(3-dc-cl, ch 3, 3-dc-cl, ch 5, 3-dc-cl, ch 3, 3-dc-cl) in ch-3 sp of next x-st, ch 3, picot, ch 3, sk next picot; rep from * 4 times, sl st in top of beg-dc-cl to join—24 cl and 6 picots. Fasten off.

SIDE DAMASK MOTIFS

Ch 6, sl st in first ch to form a ring.

Row 1 (WS): Ch 5 (counts as tr, ch-1), [2 dc in ring, ch 3] 2 times, (2 dc, ch 1, tr) in ring, turn—2 tr, 6 dc, 2 ch-3 sps and 2 ch-1 sps.

Row 2: Ch 5, [2 dc in each of next 2 dc, ch 1,

picot, ch 1, sk next ch-3 sp] 2 times; 2 dc in each of next 2 dc, ch 1, tr in 4th ch of beg ch-5, turn—2 tr, 12 dc, 2 picots and 2 ch-1 sps.

Row 3: Ch 7 (counts as tr, ch 3), sk next ch-sp, [x-st over next 4 dc, ch 3, picot, ch 3, sk next picot] 2 times; x-st over next 4 dc, ch 3, tr in 4th ch of beg ch-5, turn—2 picots and 6 ch-3 sps.

Row 4 (joining row): Ch 3, picot, ch 3, sk next ch-sp, *(3-dc-cl, ch 3, 3-dc-cl, ch 5, 3-dc-cl, ch 3, 3-dc-cl) in ch-3 sp of next x-st**, ch 3, picot, ch 3, sk next picot; rep from * once; rep from * to ** once; ch 3, picot, ch 3, sl st in 4th ch of ch-7 to join—12 cl and 4 picots. Fasten off.

END DAMASK MOTIFS

Ch 6, sl st in first ch to form a ring.

Row 1 (WS): Ch 6 (counts as dc, ch 3), [2 dc in ring, ch 3] 2 times, dc in ring—6 dc and 3 ch-3 sps.

Row 2: Ch 3 (counts as dc), dc in first dc, ch 1, picot, ch 1, sk next ch-3 sp, [2 dc in each of next 2 dc, ch 1, picot, ch 1, sk next ch-3 sp] 2 times, 2 dc in 3rd ch of beg ch-3—12 dc and 3 picots.

Row 3: Ch 2, dc in next dc, ch 6, dc in top of last dc made (beg x-st made), ch 3, picot, ch 3, [sk next picot, x-st over next 4 dc, ch 3, picot, ch 3] 2 times; sk next picot, x-st over last 2 dc—4 x-sts and 3 picots.

Row 4 (joining row): Ch 6 (counts as ch-5 sp), (3-dc-cl, ch 3, 3-dc-cl) in ch-3 sp of first x-st, ch 3, picot, ch 3, sk next picot *(3-dc-cl, ch 3, 3-dc-cl, ch 5, 3-dc-cl, ch 3, 3-dc-cl) in ch-3 sp of next x-st, ch 3, picot, ch 3, sk next picot; rep from * once more; (3-dc-cl, ch 3, 3-dc-cl) in last ch-3 sp, ch 6, sl st in 3rd ch of beg ch-6 to join—12 cl and 3 picots. Fasten off.

pattern

LACE CENTER STRIPS (*MAKE 3*)

With MC, work one Damask Motif (see Motifs) (labeled 1 on layout diagram, above), then join opposite edges of Damask Motifs into a long strip of 10. This will be the middle of the lace portion.

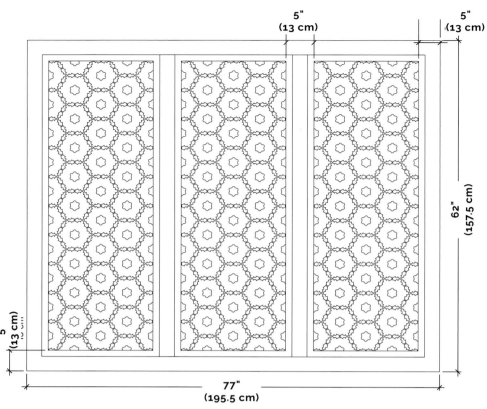

5"
(13 cm)

5"
(13 cm)

62"
(157.5 cm)

5"
(13 cm)

77"
(195.5 cm)

CONSTRUCTION DIAGRAM

DAMASK MOTIFS 2-10

Rnds 1-3: Work same as Rnds 1-3 on Damask Motif.

Rnd 4 (joining rnd): Ch 2, (2-dc-cl, ch 3, 3 dc-cl, ch 5, 3-dc-cl, ch 3, 3-dc-cl) in ch-3 sp of beg x-st, ch 3, picot, ch 3, sk next picot, [(3-dc-cl, ch 3, 3-dc-cl, ch 5, 3-dc-cl, ch 3, 3-dc-cl) in ch-3 sp of next x-st, ch 3, picot, ch 3, sk next picot] 3 times; (3-dc-cl, ch 3, 3-dc-cl, ch-5 join, 3-dc-cl, ch-3 join, 3-dc-cl) in ch-3 sp of next x-st; ch 3, picot join, ch 3, sk next picot; (3-dc-cl, ch-3 join, 3-dc-cl, ch-5 join, 3-dc-cl, ch 3, 3-dc-cl) in ch-3 sp of next x-st; ch 3, picot, ch 3, sk next picots, sl st in top of beg-dc-cl to join—24 cl and 6 picots. Fasten off.

Beg at the bottom of the first strip, work an End Damask Motif (see Motifs) (labeled A on layout diagram) at the bottom edge, as foll:

A END DAMASK MOTIF

Rep directions for Rnds 1-3 of End Damask Motif.

Rnd 4: Ch 4, sl st in adjoining motif's ch-5 sp, ch 1, (3-dc-cl, ch-3 join, 3-dc-cl) in ch-3 sp of first x-st, ch 3, picot join, ch 3, sk next picot,

(3-dc-cl, ch-3 join, 3-dc-cl, ch-5 join, 3-dc-cl, ch 3, 3-dc-cl) in ch-3 sp of next x-st, ch 3, picot, ch 3, sk next picot; (3-dc-cl, ch 3, 3-dc-cl, ch 5, 3-dc-cl, ch 3, 3-dc-cl) in ch-3 sp of next x-st, ch 3, picot, ch 3, sk next picot, (3-dc-cl, ch 3, 3-dc-cl), ch 6, sl st in 3rd ch of beg ch-6 to join—12 cl and 3 picots. Fasten off.

Join next 9 Damask Motifs as foll, then an End Motif B.

DAMASK MOTIFS 11-19

Rep directions for Rnds 1-3 of Damask Motif.

Rnd 4 (joining rnd): Ch 2, (2-dc-cl, ch 3, 3-dc-cl, ch 5, 3-dc-cl, ch 3, 3-dc-cl) in ch-3 sp of beg x-st, ch 3, picot, ch 3, sk next picot, (3-dc-cl, ch 3, 3-dc-cl, ch 5, 3-dc-cl, ch 3, 3-dc-cl) in ch-3 sp of next x-st, ch 3, picot, ch 3, sk next picot, (3-dc-cl, ch 3, 3-dc-cl, ch-5 join, 3-dc-cl, ch-3 join, 3-dc-cl) in ch-3 sp of next x-st; ch 3, picot join, ch 3, sk next picot, [(3-dc-cl, ch-3 join, 3-dc-cl, ch-5 join, 3-dc-cl, ch-3 join, 3-dc-cl) in ch-3 sp of next x-st; ch 3, picot join, ch 3, sk next picot] twice, (3-dc-cl, ch-3 join, 3-dc-cl, ch-5 join, 3-dc-cl, ch 3, 3-dc-cl) in ch-3 sp of next x-st; ch 3, picot, ch 3, sk next picots, sl st in top of beg dc-cl to join—24 cl and 6 picots. Fasten off.

56½"
(143.5 cm)

20"
(51 cm)

LACE CENTER STRIP

damask motif

side damask motif

end damask motif

Motifs can be overwhelming if you don't give yourself sense-of-accomplishment goals. I like to work one panel of motifs at a time and allow for a certain amount of time to complete that one piece—that way I don't look at the overall project and get discouraged. Instead, I have a sense of accomplishment when that one panel is done. Before you know it, all the panels are complete, and you're almost there!

—MARLY BIRD

B END DAMASK MOTIF

Rep directions for Rnds 1–3 of End Damask Motif.

Rnd 4: Ch 6, (3-dc-cl, ch 3, 3-dc-cl) in ch-3 sp of first x-st, ch 3, picot, ch 3, sk next picot, (3-dc-cl, ch 3, 3-dc-cl, ch-5 join, 3-dc-cl, ch-3 join, 3-dc-cl) in ch-3 sp of next x-st, ch 3, picot join, ch 3, sk next picot; (3-dc-cl, ch-3 join, 3 dc-cl, ch-5 join, 3-dc-cl, ch-3 join, 3 dc-cl) in ch-3 sp of next x-st, ch 3, picot join, ch 3, sk next picot, (3-dc-cl, ch-3 join, 3-dc-cl), ch 1, sl st to adjoining motif, ch 4, sl st in 3rd ch of beg ch-6 to join—12 cl and 3 picots. Fasten off.

Rep directions for A End Motif at top left corner of strip, rep directions for Damask Motifs 11–19 for Motifs 20–28, rep Directions for B End Motif.

Join Side Damask Motifs (see Motifs) to the outside edge of the large strip—28 Damask Motifs, 4 End Damask Motifs, 20 Side Damask Motifs.

SIDE DAMASK MOTIFS 1, 11

Join Motif 1 to the upper right corner and Motif 11 to the lower left corner.

Rep Rnds 1–3 of Side Motif.

Row 4 (joining row): Ch 3, picot, ch 3, sk next ch-sp, (3-dc-cl, ch 3, 3-dc-cl, ch-5 join, 3-dc-cl, ch-3 join, 3-dc-cl) in ch-3 sp of next x-st, ch 3, picot join, ch 3, sk next picot, (3-dc-cl, ch-3 join, 3-dc-cl, ch-5 join, 3-dc-cl, ch-3 join, 3-dc-cl) in ch-3 sp of next x-st, ch 3, picot join, ch 3, sk next picot, (3-dc-cl, ch-3 join, 3-dc-cl, ch-5 join, 3-dc-cl, ch 3, 3-dc-cl) in ch-3 sp of next x-st, ch 3, picot, ch 3, sl st in 4th ch of ch-7 to join—12 cl and 4 picots. Fasten off.

SIDE DAMASK MOTIFS 2–10, 12–20

Work 2–10 Motifs on upper edge and 12–20 on lower edge.

Rep Rnds 1–3 of Side Motif.

Row 4 (joining row): Ch 3, picot, ch 3, sk next ch-sp, (3-dc-cl, ch 3, 3-dc-cl, ch-5 join, 3-dc-cl, ch-3 join, 3-dc-cl) in ch-3 sp of next x-st, ch 3, picot join, ch 3, sk next picot, (3-dc-cl, ch-3 join, 3-dc-cl, ch-5 join, 3-dc-cl, ch-3 join, 3-dc-cl) in ch-3 sp of next x-st, ch 3, picot join, ch 3, sk next picot, (3-dc-cl, ch-3 join, 3-dc-cl, ch-5 join, 3-dc-cl, ch-3 join, 3-dc-cl) in ch-3 sp of next x-st, ch 3, picot join, ch 3, sl st in 4th ch of ch-7 to join—12 cl and 4 picots. Fasten off.

NOTE: Wet-block strips at this point to make it easier to work the border.

border

CENTER STRIP BORDERS

With RS facing, join MC with sl st in short edge corner of center strip, ch 1, sc evenly around, working a multiple of 6 sts, sl st in first sc to join, changing to CC2.

NOTE: From here on work each side border in rows from corner to corner.

FIRST SHORT SIDE EDGING

Treating each sc as a base ch-sp, work Row 1 of Border Patt (see Motifs) along the short edge only, ending with sc in corner st, turn. Work Rows 2–3 of Border patt across short edge. At end of last row, fasten off.

SECOND SHORT SIDE EDGING

With RS facing, join CC2 with sl st in right corner on opposite short edge; rep First Short Side Edging across 2nd side edge.

FIRST LONG SIDE EDGING

With RS of center strip facing, join CC2 with sl st in corner st on one long edge, treating each sc as a base ch work Row 1 of Border patt to corner, ending with sc in corner st, turn. Work in Border patt for 2 more rows**, then change to CC1 and work in Border patt for 5 rows. At end of last row, fasten off.

SECOND LONG SIDE EDGING

With RS facing and on Side Damask Motifs of 1 lace center strip, rep First Long Side Edging.

END STRIP BORDERS

End Strips have 5 extra rows on outside edge of long side edging.

Work same as Center Strip borders through ** on Second Long Side Edging, then change to CC1 and work in Border patt for 10 rows. At end of last row, fasten off.

ASSEMBLE STRIPS

Seaming Row: With RS tog, matching the narrow border of one end strip (with only 5 rows of CC1) to one long side of center strip, join CC1 at right end of long edge, ch 1, working through double thickness, sc in each st across. Rep seaming row across other end strip and other side of center strip.

NOTE: This should place the 2 borders with 10 rows of CC1 on the outer edges of the blanket.

FINAL BORDER

Working across all 3 strips, join CC1 with sl st to right corner of one long edge, work Row 1 of Border patt, ending with sc in corner st, turn. Work Border Patt for 9 more rows. At end of last row, fasten off.

Rep final Border across opposite long side edge of afghan.

PICOT EDGING

Rnd 1: With RS facing, join CC2 with sl st in any corner, ch 1, *sc in each of next 3 sts, picot; rep from * around, sl st in first sc to join. Fasten off.

finishing

Weave in loose ends. Spray block.

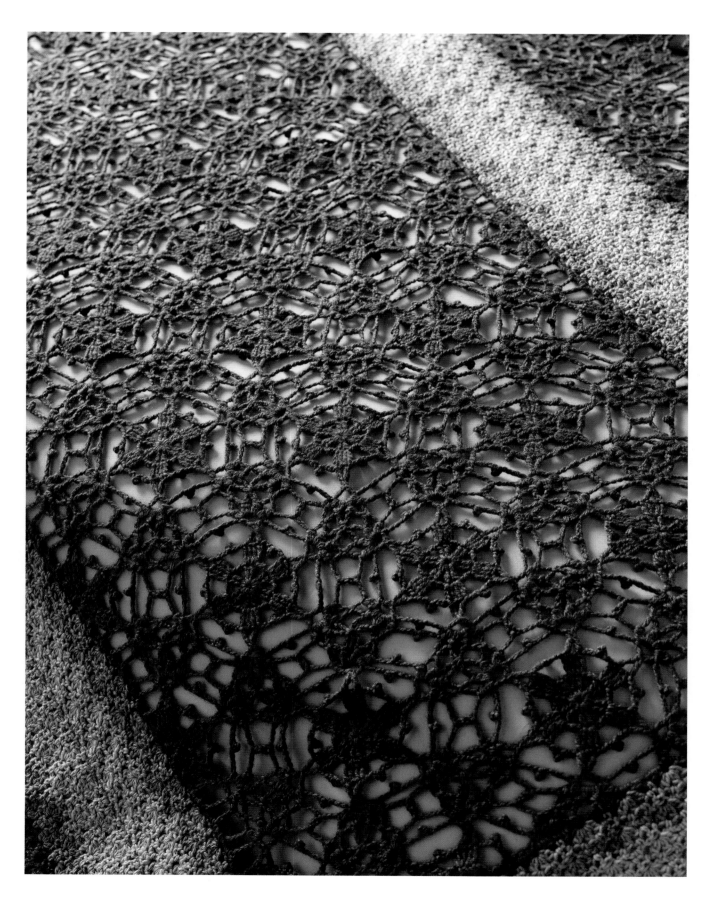

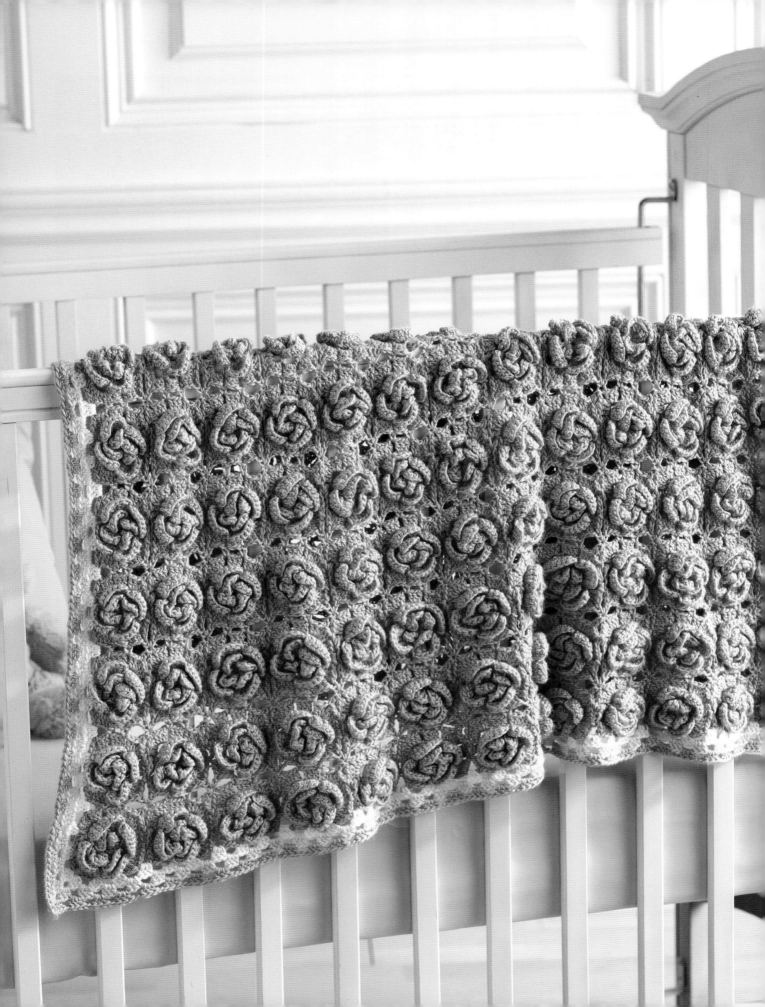

BUTTERCUP
blanket

DESIGNED BY KRISTIN OMDAHL

This three-dimensional flower motif creates the perfect texture to wrap up and snuggle with your little bundle of joy. The two-tiered flowers have a whimsical, feminine appeal for your favorite girly-girl. The motifs also serve to make a surprisingly dense fabric that is warm and cozy. The simple edging creates a nice contrast with the body of the blanket and provides an attractive, crisp finish.

FINISHED SIZE
30" x 35" (76 x 91.5 cm).

YARN
DK weight (#3 Light).

SHOWN HERE: Naturally Caron, Spa (25% rayon from bamboo/ 75% microdenier acrylic; 251 yd [230 m]/ 3 oz [85 g]): #0002 coral lipstick (MC), 7 balls; #0007 naturally (A); #0003 soft sunshine (B); and #0001 rose bisque (C), 1 ball each.

HOOK
H/8 (5 mm) or size needed to obtain gauge.

NOTIONS
Tapestry needle for weaving in ends.

GAUGE
1 motif = 2½" (6.5 cm) square after blocking.

NOTE
✦ If making blanket with one color only, 8 balls of MC are required.

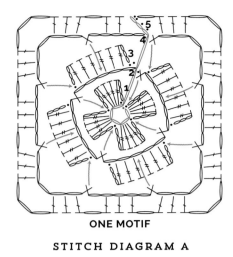

ONE MOTIF

STITCH DIAGRAM A

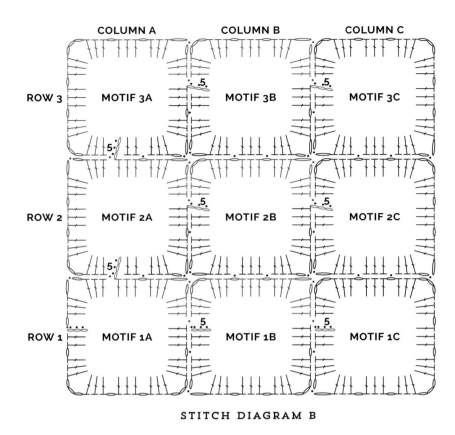

STITCH DIAGRAM B

buttercup motif

Refer to Stitch Diagram A for assistance.

MOTIF 1A

Rnd 1: Ch 5 + 1 + 1 + 3 = 10, sl st in 5th ch from hook to form ring. Sl st in ring, [ch 3, 4 tr, ch 3, sl st] 4 times in ring.

Rnd 2: Sl st in next ch of beg ch, *ch 5, working behind petals of Rnd 1, sc in next sl st. Rep from * 3 times.

Rnd 3: *(Sl st, ch 3, 6 tr, ch 3, sl st) in next ch-5 sp. Rep from * 3 times, sl st to first sl st to join.

Rnd 4: Sl st in next ch of beg ch (counts as sc), *ch 5, working behind petals of Rnd 3, sc in next ch-5 sp bet 3rd and 4th tr in Rnd 2. Ch 5, sc in next sl st. Rep from * 3 times.

Rnd 5: Sl st into next ch-5 sp, sl st in ea of last 3 chs of beg ch (counts as dc), 2 dc in next

ch-5 sp, *ch 1, (3 dc, ch 3, 3 dc) in next ch-5 sp, ch 1, 3 dc in next ch-5 sp, rep from * once.

MOTIF 1B

Rnds 1–4: Rep Rnds 1–4 of Motif 1A.

Rnd 5: Sl st in ea of last 3 chs of beg ch (counts as dc), 2 dc in next ch-5 sp, sl st in ch-1 sp on adjacent motif (Motif 1A),*(3 dc, ch 1, sl st in ch-3 sp on adjacent motif, ch 1, 3 dc) in next ch-5 sp, ch 1, 3 dc in next ch-5 sp, ch 1, (3 dc, ch 3, 3 dc) in next ch-5 sp, ch 1, 3 dc in next ch-5 sp.

MOTIF 1C

Rnds 1–4: Rep Rnds 1–4 of Motif 1A.

Rnd 5: Sl st in ea of last 3 chs of beg ch (counts as dc), 2 dc in next ch-5 sp, sl st in ch-1 sp on adjacent motif (Motif 2A), (3 dc, ch 1, sl st in ch-3 sp on adjacent motif, ch 1, 3 dc) in next ch-5 sp, *ch 1, 3 dc in next ch-5 sp, ch

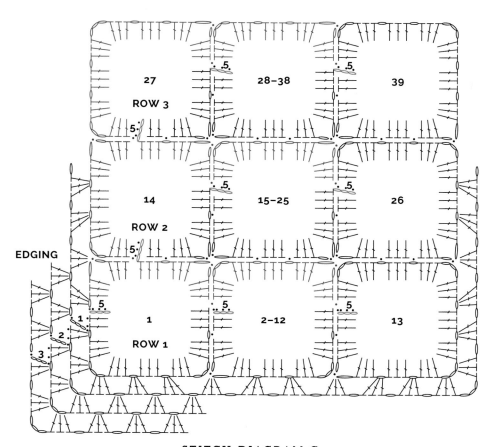

STITCH DIAGRAM C

1, (3 dc, ch 3, 3 dc) in next ch-5 sp. Rep from *
twice.

Working across incomplete motifs in row 1, sl
st in sp bet current and adjacent motifs, (3 dc,
ch 1, sl st in ch-3 sp of adjacent Motif 1C, ch
1, 3 dc) in next ch-5 sp, ch 1, 3 dc in next ch-5
sp, ch 1, (3 dc, ch 3, 3 dc) in next ch-5 sp, sl st
in sp bet current and adjacent motifs, working
in next motif (Motif 1A) (3 dc, ch 1, sl st in ch-3
sp of adjacent Motif 1B, ch 1, 3 dc) in next ch-5
sp, ch 1, 3 dc in next ch-5 sp.

MOTIF 2A

Rnds 1–4: Rep Rnds 1–4 of Motif 1A.

Rnd 5: Sl st in ea of last 3 chs of beg ch
(counts as dc), 2 dc in next ch-5 sp, sl st in
ch-1 sp on adjacent motif (Motif 1A), (3 dc, ch
1, sl st in ch-3 sp on adjacent motif, ch 1, 3 dc)
in next ch-5 sp, sl st in ch-1 sp on adjacent
motif, ch 1, 3 dc in next ch-5 sp.

MOTIF 2B

Rnds 1–4: Rep Rnds 1–4 of Motif 1A.

Rnd 5: Sl st in ea of last 3 chs of beg ch
(counts as dc), 2 dc in next ch-5 sp, sl st in
ch-1 sp on adjacent motif (Motif 1B), (3 dc, ch
1, sl st in ch-3 sp on adjacent motif, ch 1, 3 dc)
in next ch-5 sp, sl st in ch-1 sp on adjacent
motif (Motif 2A), 3 dc in next ch-5 sp, sl st in
ch-1 sp on adjacent motif, (3 dc, ch 1, sl st in
ch-3 sp on adjacent motif, ch 1, 3 dc) in next
ch-5 sp, ch 1, 3 dc in next ch-5 sp.

MOTIF 2C

Rnds 1–4: Rep Rnds 1–4 of Motif 1A.

Rnd 5: Sl st in ea of last 3 chs of beg ch
(counts as dc), 2 dc in next ch-5 sp, sl st in
ch-1 sp on adjacent motif (Motif 2B), (3 dc, ch
1, sl st in ch-3 sp on adjacent motif, ch 1, 3 dc)
in next ch-5 sp, sl st in ch-1 sp on adjacent
motif (Motif 2B), 3 dc in next ch-5 sp, sl st in
ch-1 sp on adjacent motif, (3 dc, ch 1, sl st in

ch-3 sp on adjacent motif, ch 1, 3 dc) in next ch-5 sp, ch 1, *3 dc in next ch-5 sp, (3 dc, ch 3, 3 dc) in next ch-5 sp. Rep from * once.

Working across incomplete motifs in row 2, sl st in sp bet current and adjacent motifs, (3 dc, ch 1, sl st in ch-3 sp of adjacent motif, ch 1, 3 dc) in next ch-5 sp, ch 1, 3 dc in next ch-5 sp, (3 dc, ch 3, 3 dc) in next ch-5 sp, sl st in sp bet current and next motif, (3 dc, ch 1, sl st in ch-3 sp of adjacent motif, ch 1, 3 dc) in next ch-5 sp, ch 1, 3 dc in next ch-5 sp.

MOTIF 3A

Rep Motif 2A.

MOTIF 3B

Rep Motif 1B.

MOTIF 3C

Rep Motif 2C.

Working across incomplete motifs in row 3, sl st in sp bet current and next motif, (3 dc, ch 1, sl st in ch-3 sp of adjacent motif, ch 1, 3 dc) in next ch-5 sp, ch 1, 3 dc in next ch-5 sp, (3 dc, ch 3, 3 dc) in next ch-5 sp.

Working across incomplete motifs in Column A, *sl st in sp bet current and next motif, (3 dc, ch 1, sl st in ch-3 sp of adjacent motif, ch 1, 3 dc) in next ch-5 sp, ch 1, 3 dc in next ch-5 sp, (3 dc, ch 3, 3 dc) in next ch-5 sp * once, ch 1, 3 dc in next ch-5 sp, ch 1, (3 dc, ch 3, 3 dc) in next ch-5 sp. Rep from * to * once. Sl st in sp bet current and next motif, (3 dc, ch 1, sl st in ch-3 sp of adjacent motif, ch 1, 3 dc) in next ch-5 sp, ch 1, sl st in first ch of beg ch-3 on Motif 1A.

Fasten off. Weave in loose ends.

buttercup baby blanket

Refer to the instructions for the Buttercup Motif on page 46 for motifs referenced in these instructions; refer to Stitch Diagram C (page 47) for assistance.

MOTIF 1

Work same as Motif 1A.

MOTIFS 2–12

Work same as Motif 1B.

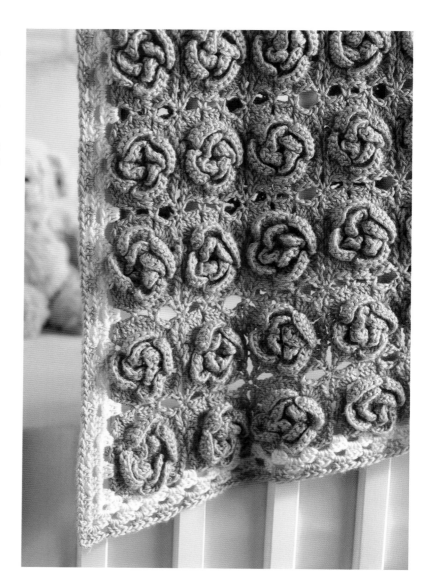

MOTIF 13

Work same as Motif 1C.

COMPLETION ROW

Working across incomplete motifs in row 1, *sl st in sp bet current and adjacent motifs, (3 dc, ch 1, sl st in ch-3 sp of adjacent motif, ch 1, 3 dc) in next ch-5 sp, ch 1, 3 dc in next ch-5 sp, ch 1, (3 dc, ch 3, 3 dc) in next ch-5 sp. Rep from * 10 times, sl st in sp bet current and adjacent motifs, working in next motif (3 dc, ch 1, sl st in ch-3 sp of adjacent motif, ch 1, 3 dc) in next ch-5 sp, ch 1, 3 dc in next ch-5 sp.

MOTIF 14

Work same as Motif 2A.

MOTIFS 15-25

Work same as Motif 2B.

MOTIF 26

Work same as Motif 2C.

COMPLETION ROW

Working across incomplete motifs in row 2, *sl st in sp bet current and adjacent motifs, (3 dc, ch 1, sl st in ch-3 sp of adjacent motif ch 1, 3 dc) in next ch-5 sp, ch 1, 3 dc in next ch-5 sp, ch 1, (3 dc, ch 3, 3 dc) in next ch-5 sp. Rep from * 10 times, sl st in sp bet current and adjacent motifs, working in next motif (3 dc, ch 1, sl st in ch-3 sp of adjacent motif, ch 1, 3 dc) in next ch-5 sp, ch 1, 3 dc in next ch-5 sp.

MOTIFS 27-143

Rep Motifs 14–26 nine times.

COMPLETION ROW

Working across incomplete motifs in last row, *sl st in sp bet current and next motif, (3 dc, ch 1, sl st in ch-3 sp of adjacent motif, ch 1, 3 dc) in next ch-5 sp, ch 1, 3 dc in next ch-5 sp, (3 dc, ch 3, 3 dc) in next ch-5 sp*. Rep from * to * 10 times, ch 1, 3 dc in next ch-5 sp, ch 1, (3 dc, ch 3, 3 dc) in next ch-5 sp. Rep from * to * 8 times. Sl st in sp bet current and next motif, (3 dc, ch 1, sl st in ch-3 sp of adjacent motif, ch 1, 3 dc) in next ch-5 sp, ch 1, sl st in first ch of beg ch-3 on Motif 1. Do not fasten off.

EDGING

NOTE: If you are making the blanket in one color, follow Rnds 1–3 of Edging as written. If you are making the blanket with a multicolored edging, work Rnd 1 with A, Rnd 2 with B, and Rnd 3 with C. Fasten off the yarn after each rnd and join new color with sl st in first ch-1 sp.

Rnd 1: Sl st in next 2 dc, sl st in next ch-1 sp, ch 3 (counts as dc), 2 dc in same sp, ch 1, **(3 dc, ch 3, 3 dc) in next corner ch-3 sp, (3 dc, ch 1) in ea of next 2 ch-1 sps, *3 dc in sp bet motifs, ch 1, (3 dc, ch 1) in ea of next 2 ch-1 sps. Rep from * across to next ch-3 corner. Rep from ** around, join with sl st to top of beg ch-3–4 ch-3 corners.

Rnds 2–3: Sl st in next 2 dc, sl st in next ch-1 sp, ch 3 (counts as dc), 2 dc in same sp, ch 1, **(3 dc, ch 3, 3 dc) in next corner ch-3 sp, (3 dc, ch 1) in ea ch-1 sp across to next ch-3 corner. Rep from ** around, join with sl st to top of beg ch-3–4 ch-3 corners. Fasten off. Weave in ends.

Block to finished measurements and let dry.

NOTE: Due to the durable nature of the fiber in this yarn, the washing machine can be used for wet blocking.

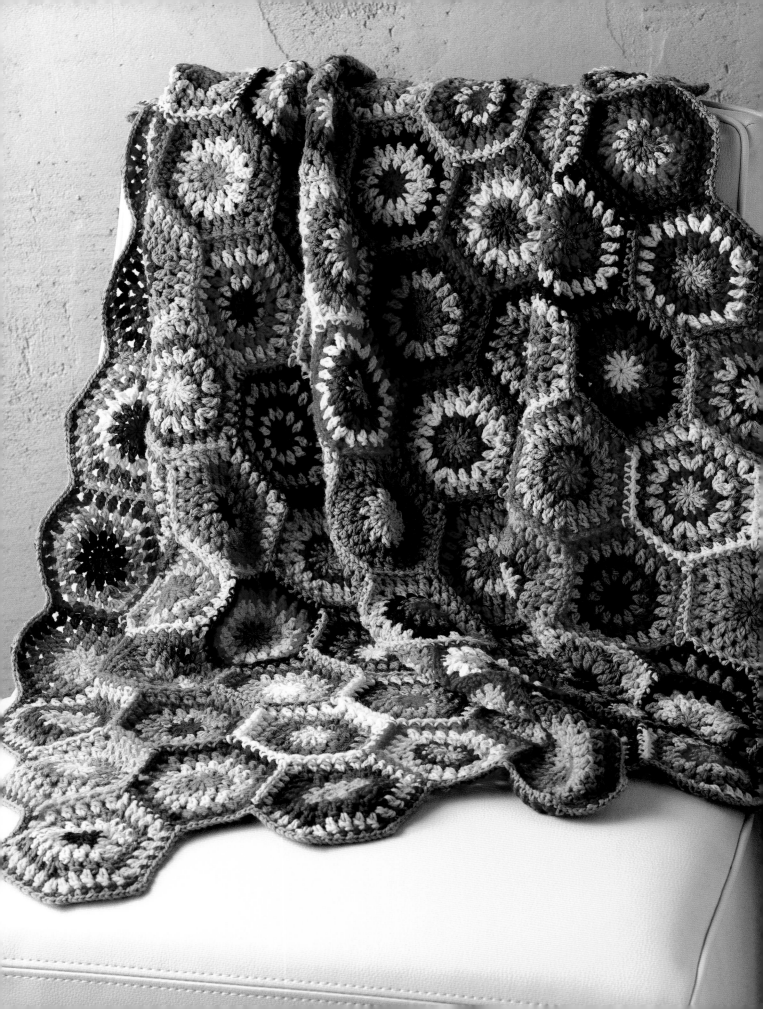

HAPPY HEXAGONS
throw

DESIGNED BY **MARYSE ROUDIER**

Bold, graphic motifs in a riot of bright colors make this blanket 100 percent fun to make and display in your home. The large number of colors is what makes this afghan so special, so don't feel shy about selecting this many hues—check out some color tips in the sidebar on page 55.

FINISHED SIZE
56" wide × 48" long
(142 × 122 cm).

YARN
Worsted weight (#4 Medium).

SHOWN HERE: Cascade Yarns Cascade 220 (100% Peruvian Highland wool, 220 yd [201 m]/100 g), in brown (#2403 chocolate), in blues (#7816 bluebell, #8339 marine, #8892 azure, #8907 Caribbean, #8908 anis, #9427 duck egg blue), in greens (#2409 palm, #8910 citron, #8914 granny smith, #9430 Highland green, #9566 olive oil), in orange

(#7824 Jack o'lantern), in pinks (#7804 shrimp, #9469 hot pink), in purples (#7808 purple hyacinth, #8912 lilac mist, #9570 Concord grape, #9571 misty llac), in reds (#2413 red, #9552 maroon, #9565 koi), in yellows (#2439 gelato, #4147 lemon yellow, #7827 goldenrod, #9496 buttercup), 1 hank each.

HOOK
Size H/8 (5 mm), or size needed to obtain gauge.

NOTIONS
Tapestry needle.

GAUGE
4 rnds of hexagon motif = 4" (10 cm) in diameter. Take time to check your gauge.

NOTES
+ Work Rnds 1 to 4 of hexagon patt with choice of colors A, B, C, and D. See instructions for working Rnd 5 and joining.
+ When changing colors or joining a new yarn, crochet over ends to save time.

throw

STRIP 1 (11 MOTIFS)

1ST MOTIF

Rnds 1–4: Work Rnds 1 to 4 of hexagon motif patt with choice colors A, B, C, and D.

Rnd 5: Join color E in any ch-3 corner sp, (beg CL, ch 3, CL, ch 1) in same sp, *(CL, ch 1) in each of next 3 ch-1 sps, (CL, ch 3, CL, ch 1) for corner in next ch-3 sp; rep from * 4 times more, (CL, ch 1) in each of last 3 ch-1 sps, join with sl st in 2nd ch of beg t-ch, fasten off.

2ND MOTIF

Rnds 1–4: Work Rnds 1 to 4 of hexagon motif patt with choice colors A, B, C, and D.

Row 5 (Joining): Join color E in any ch-3 corner sp, (beg CL, ch 3, CL, ch 1) in same sp. *(CL, ch 1) in each of next 3 ch-1 sps, (CL, ch 3, CL, ch 1) in next ch-3 corner space; rep from * twice more, (CL, ch 1) in each of next 3 ch-1 sps, (CL, ch 1) in next ch-3 corner sp, sl st in ch-3 corner sp of previous motif, (ch 1, CL) in same ch-3 sp of current motif, [sl st in next ch-1 sp of previous motif, (CL, ch 1) in next ch-1 sp of current motif] 3 times. Sl st in next ch-1 sp of previous motif, (CL, ch 1) in ch-3 corner sp of current motif, sl st in ch-3 corner sp of previous motif, (ch 1, CL) in same ch-3 corner sp of current motif, (ch 1, CL) in each of next 3 ch-1 sps of current motif, ch 1, join with sl st in 2nd ch of beg t-ch, fasten off.

3RD TO 11TH MOTIFS

Rep as for 2nd Motif working Rnds 1–4 for motif and joining in Rnd 5 to previous motif.

Lay Strip 1 aside with RS facing up.

STRIP 2 (11 MOTIFS)

1ST MOTIF

Rnds 1–4: Work Rnds 1–4 of hexagon patt.

Rnd 5 (Joining): Join color E in any ch-3 corner sp, (beg CL, ch 3, CL, ch 1) in same sp, *(CL, ch 1) in each of next 3 ch-1 sps, (CL, ch 3, CL, ch 1) in next ch-3 corner sp, (CL, ch 1) in each of next 3 ch-1 sps, (CL, ch 1) in next ch-3 corner sp, sl st in ch-3 corner sp of 1st Motif of Strip 1, (ch 1, CL) in same ch-3 sp of current motif, [sl st in next ch-1 sp of 1st Motif of Strip 1, (CL, ch 1) in next ch-1 sp of current motif] 3 times, sl st in next ch-1 sp of 1st Motif of Strip 1, (CL, ch 1) in ch-3 corner sp of current motif, sl st in both ch-3 corner sps of 1st Motif of Strip 1 and 2nd Motif of Strip 1, (ch 1, CL) in same ch-3 corner sp of current motif, [sl st in next ch-1 sp of 2nd Motif of Strip 1, (CL, ch 1) in ch-1 sp of current motif] 3 times, sl st in next ch-1 sp of 2nd Motif of Strip 1, (CL, ch 1 in ch-3 corner sp of current motif, sl st in ch-3 sp of 2nd Motif of Strip 1, (ch 1, CL) in same ch-3 corner sp, (ch 1, CL) in each of next 3 ch-1 sps of current motif, ch 1, (CL, ch-3, CL, ch 1) in ch-3 corner sp, (ch 1, CL) in each of next 3

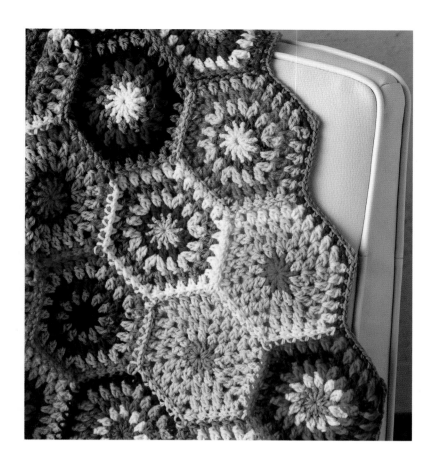

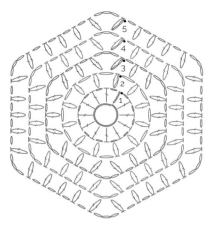

HEXAGON MOTIF

CHART KEY

◯ = chain (ch)

| = double crochet (dc)

• = slip stitch (sl st)

⬮ = beginning cluster (beg CL)

⬯ = cluster (CL)

← = joining

ch-1 sps, ch 1, join with sl st in 2nd ch of beg t-ch, fasten off.

2ND MOTIF

Rnds 1–4: Work Rnds 1–4 of hexagon patt.

Rnd 5 (Joining): Join color E in any ch-3 corner sp, (beg CL, ch 3, CL, ch 1) in same sp, *(CL, ch 1) in each of next 3 ch-1 sps, (CL, ch 1) in next ch-3 corner sp, sl st in ch-3 corner sp of 1st Motif of Strip 2, (ch, CL) in same ch-3 corner sp of current motif, (CL, ch 1) in each of next 3 ch-1 sps, (CL, ch 1) in next ch-3 corner sp, sl st in ch-3 corner sp of 1st Motif of Strip 1, (ch 1, CL) in same ch-3 sp of current motif, [sl st in next ch-1 sp of 1st Motif of Strip 2, (CL, ch 1) in next ch-1 sp of current motif] 3 times, sl st in next ch-1 sp of 1st Motif of Strip 2, (CL, ch 1) in ch-3 corner sp of current motif, sl st in both ch-3 corner sps of 1st Motif of Strip 2 and 2nd Motif of Strip 1, (ch 1, CL) in same ch-3 corner sp of current motif, [sl st in next ch-1 sp of 2nd Motif of Strip 1, (CL, ch 1) in ch-1 sp of current motif] 3 times, sl st in next ch-1 sp of 2nd Motif of Strip 1, (CL, ch 1) in ch-3 corner

sp of current motif, sl st in both ch-3 corner sp of 2nd Motif of Strip 1 and ch-3 corner sp of 3rd Motif of Strip 1, (ch 1, CL) in same ch-3 corner sp of current motif, [sl st in next ch-1 sp of 3rd Motif of Strip 1, (ch 1, CL) in ch-1 sp of current motif] 3 times, sl st in next ch-1 sp of 3rd Motif of Strip 1, (CL, ch 1) in ch-3 corner sp of current motif, sl st in ch-3 corner sp of 3rd Motif of Strip 1, (ch 1, CL) in same ch-3 corner sp of current motif, (ch 1, CL) in each of next 3 ch-1 sps, (ch 1, CL, ch 3, CL) in next ch-3 corner sp, (ch, CL) in each of next ch-1 sp, ch 1, join with sl st in 2nd ch of beg t-ch, fasten off.

3RD TO 11TH MOTIFS

Foll diagram, rep as for 2nd Motif working Rnd 5 and joinings to Strip 1.

STRIPS 3 TO 11

Rep as for Strip 2 foll diagram, working Rnd 5 and joinings to previous completed strips.

JOINING MOTIFS

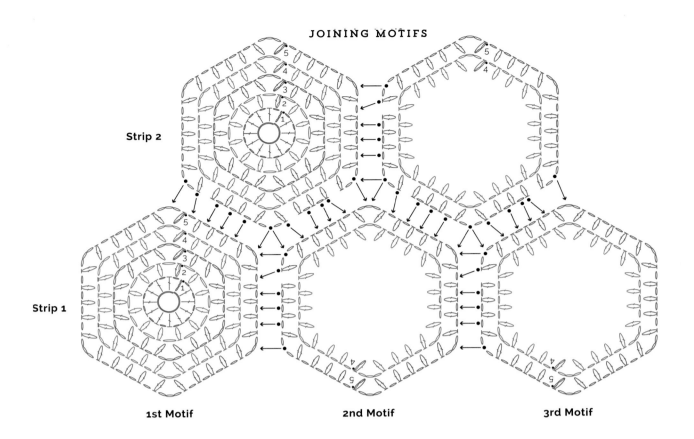

Strip 2

Strip 1

1st Motif **2nd Motif** **3rd Motif**

EDGING

With RS facing, join color F in any ch-1 sp along edge.

Rnd 1 (RS): Ch 3 (counts as hdc and ch 1), work (1 hdc, ch 1) in each ch-1 sp, (1 hdc, ch 1) in each ch-3 sp where joined, and (3 hdc, ch 1) in each ch-3 corner sp (points) around, join with sl st in 2nd ch of beg t-ch, do not turn, fasten off.

Rnd 2: Join color G to any ch-1 sp, ch 1, (1 sc, ch 1) in same sp, (1 sc, ch 1) in each ch-1 sp and (3 sc, ch) in center hdc of each 3-hdc group around, join with sl st in first sc, fasten off.

finishing

Weave in ends.

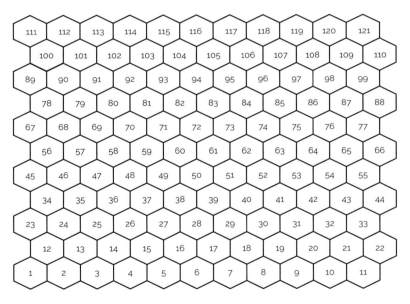

CONSTRUCTION DIAGRAM

CHOOSING COLORS

The colors in this afghan are placed randomly as you stitch; there's no specific color pattern to follow, and there's no right or wrong way to select your own hues. Here are a few tips to help you select successful shades.

❖ To get the same jewel effect as in this blanket, be sure to choose strong, vibrant colors. It's okay to add in a few different tones as accents, but overall keep the colors vivid rather than muted.

❖ In each hex, try to use a balanced mix of warm (orange, yellow, red) and cool (blue, green, purple) colors.

❖ It helps to have a color wheel nearby as you crochet. Complementary colors—colors that are opposite each other in the color wheel (red and green, for example)—are guaranteed to always look great together. So if you work the first round in one color, work the next round in a color that is opposite on the wheel.

❖ Believe it or not, adding a couple of "ugly" colors makes things interesting! So if you're working with all jewel tones, add a murky olive or a 1970s-inspired gold. It'll make those "prettier" colors pop.

❖ For a more cohesive and slightly less mismatched look, try using a neutral such as black, gray, white, or tan as the first or last round of every hex.

❖ Don't be afraid of making crazy mixes; experiment with your colors as you work and take some chances! You may find that some of your hexagons will leave you cold. You may want to trash them, but resist the urge. Once you put all of the hexes together, they'll blend into something really fabulous.

❖ Try to keep the blanket as a whole color-balanced. In other words, avoid having your blue-dominant hexes in one corner and your reds in another.

❖ Have fun with it! Let yourself be free to play with the colors, and you may be surprised by the result.

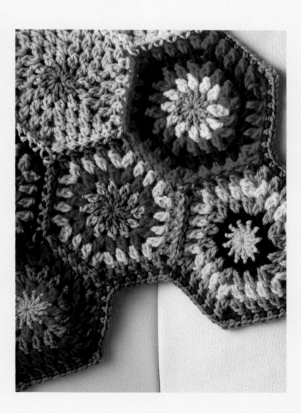

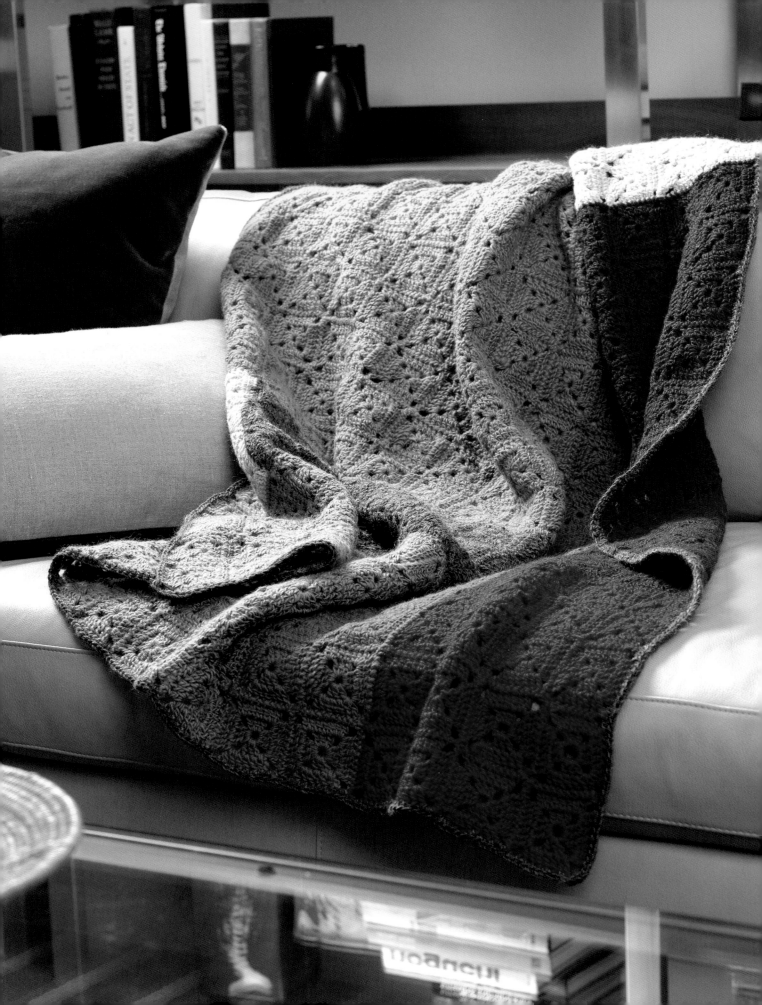

BEHRENS COLORBLOCK
afghan

DESIGNED BY **LEIGH RADFORD**

Designer Leigh Radford was inspired by some of her favorite things—color, traditional techniques, and quick and easy projects—to create this color-block blanket comprised of double crochet squares. Arranging the squares into a color-block pattern was the perfect way to update this time-honored stitch pattern. Follow the diagram (on page 58) or be adventurous and create a color-block pattern of your own—the possibilities are endless.

FINISHED SIZE

45" x 60" (114.5 x 152.5 cm).

YARN

Worsted weight
(#4 Medium).

SHOWN HERE: Brown Sheep Lamb's Pride (85% wool, 15% mohair; 190 yd [173 m]/4 oz [113 g]): M83 raspberry (A), 3 skeins; M177 Olympic bronze (B), 2 skeins; M18 khaki (C), 3 skeins; M140 Aran (D), 1 skein; M171 fresh moss (E), 5 skeins; M04 charcoal heather (F), 2 skeins; M89 roasted coffee (G), 2 skeins.

HOOK

H/8 (5 mm) or size needed to obtain gauge.

NOTIONS

Tapestry needle for weaving in ends; spray bottle with water and straight pins for blocking.

GAUGE

One square = 2½" x 2½" (6.5 x 6.5 cm).

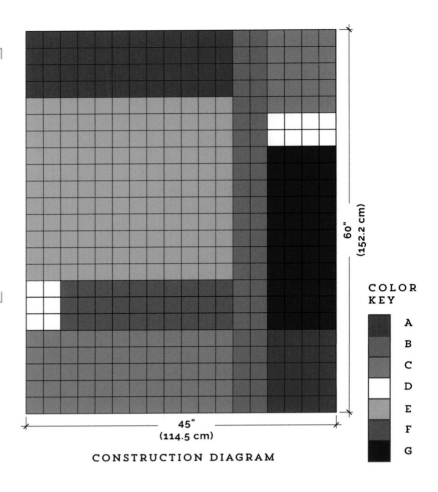

CONSTRUCTION DIAGRAM

COLOR KEY

A
B
C
D
E
F
G

60"
(152.2 cm)

45"
(114.5 cm)

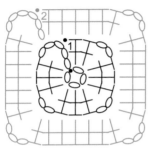

DC SQUARE

pattern

Make the foll number of double crochet squares (see Stitch Guide) in the foll colors:

Color A: 68
Color B: 46
Color C: 80
Color D: 14
Color E: 132
Color F: 30
Color G: 44

finishing

BLOCKING AND SEAMING

Following Construction Diagram (above), assemble 1 row of squares at a time, as foll: With WS tog and using tapestry needle and yarn color of your choice, whipstitch squares tog. Once all squares are sewn into rows, with WS tog, whipstitch rows tog.

EDGING

With RS facing, join F in first st to the left of any corner ch-sp, ch 1, *sc in each st across to next corner, working 2 sc in each ch-sp, 5 sc in corner sp; rep from * around, sl st in first sc to join, fasten off.

Weave in loose ends and block to measurements.

I crochet very loose chains. To combat this, when transitioning from one round to the next in granny squares, I use a smaller hook to work the chains to set up the next round. Once I've completed the chains, I change back to the larger hook to complete the round. If you make very tight chains, try using a larger hook. —LEIGH RADFORD

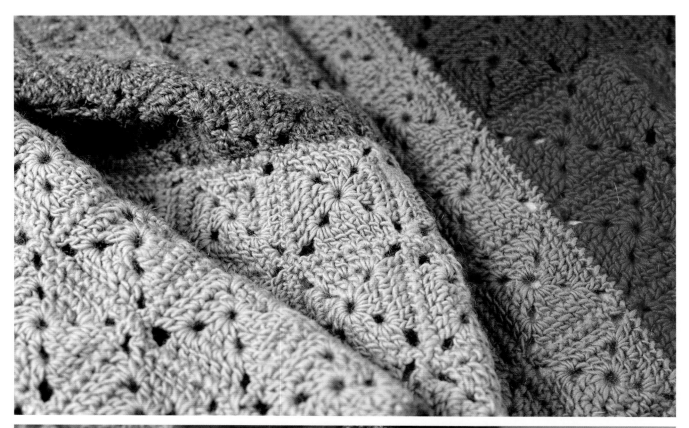

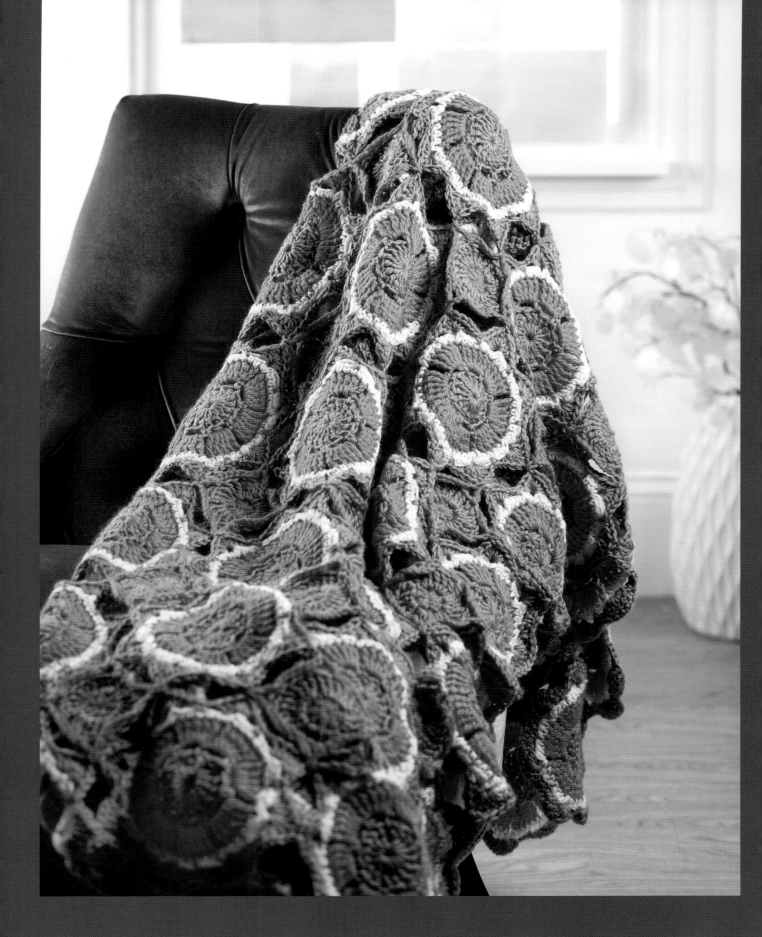

REFLECTED SUNLIGHT
afghan

DESIGNED BY ELLEN GORMLEY

When you combine a motif named *Oro Sol,* Spanish for "golden sun," with the Puddles Gather Rain motif, you get a stunning mosaic of color and depth—like sun reflected in the water. An easy join-as-you-go technique makes the assembly quick and simple.

FINISHED SIZE
47"× 61" (119 × 155 cm).

YARN
Worsted weight (#4 Medium).

SHOWN HERE: Universal Yarns Deluxe Worsted (100% wool; 220 yd [200 m]/3½ oz [100 g]): #12204 pussywillow gray (A), 6 skeins; #41795 nectarine (B), 5 skeins; #12257 pulp (C), 2 skeins.

HOOK
Size K/10½ (6.5mm) crochet hook or any size to obtain gauge.

NOTIONS
Yarn needle.

GAUGE
Octagons: Rnds 1–2 in pattern = 2¾" (7 cm).

Squares: Rnds 1–2 in pattern = 2" (5 cm).

NOTE
✦ All rounds are worked on the right side.

CONSTRUCTION DIAGRAM

motif A

ORO SOL

Make 63.

With color A, ch 4, join with sl st to form ring.

Rnd 1: Ch 4, (counts as tr throughout) 15 tr in ring; join with sl st in top of beg ch-4—16 tr.

Rnd 2: Ch 1, sc in same st; *ch 3, skip next st, sc in next st; rep from * 6 more times, ch 3; join with sl st in first sc—8 sc and 8 ch-3 sps. Fasten off.

Rnd 3: Join B with sl st in any ch-3 sp, ch 4, 4 tr in same sp, ch 1, skip next st; *5 tr in next ch-3 sp, ch 1, skip next st; rep from * 6 more times; join with sl st in top of beg ch-4—40 tr and 8 ch-1 sps. Fasten off.

Rnd 4: Join C with sc in any ch-1 sp, ch 3, sc in same sp; *sc in next 5 sts, (sc, ch 3, sc) in next ch-1 sp; rep from * 6 more times, sc in last 5 sts; join with sl st in first sc-56 sc and 8 ch-3 sps. Fasten off.

Joining rnd: Lay out octagons in 7 rows of 9. Work Round 5, using stitch diagram and Construction Diagram for assistance, work

connecting petals as follows: In this case, a petal is defined as a 7-dc group.

FIRST MOTIF (NOT JOINED TO ANY OTHER)

Rnd 5: Join A with sl st in any ch-3 sp, ch 3 (counts as dc), 6 dc in same sp; *ch 1, skip next 3 sts, sc in next st, ch 1, skip next 3 sts, 7 dc in next ch-3 sp; rep from * 6 more times, ch 1, skip next 3 sts, sc in next st, ch 1, skip next 3 sts; join with sl st in top of beg ch-3—56 dc and 8 sc.

NOTE: Subsequent motifs (joined on 2 petals of every adjacent octagon): Take care to join on every dc-7 group necessary.

Rnd 6: Join A with sl st in any ch-3 sp, ch 3 (counts as dc), 6 dc in same sp; *ch 1, skip next 3 sts, sc in next st, ch 1, skip next 3 sts, 4 dc in ch-3 sp, sl st in middle dc of adjacent petal on second motif, 3 dc in same ch-3 sp; rep from * twice on each adjacent octagon, **ch 1, skip next 3 sts, sc in next st, ch 1, skip next 3 sts, 7 dc in next ch-3 sp; rep from ** around, ch 1, skip next 3 sts, sc in next st, ch 1, skip next 3 sts; join with sl st in top of beg-ch—56 dc and 8 sc.

motif B

PUDDLES GATHER RAIN SQUARE

Make 48.

With B, ch 4.

Rnd 1: 7 dc in the 4th ch from hook; join with sl st in 4th ch of beg ch-4—8 dc. Fasten off.

Rnd 2: Join A with sl st in any st, ch 4 (counts as tr), 2 tr in same st; 3 tr in each of next 7 sts; join with sl st in top of beg ch-4—24 tr. Fasten off.

After all the octagons are joined to one another, all square inserts are added and joined to 4 octagons (see Construction Diagram)

Rnd 3: Join B with sc in any st; ch 2, sl st in join where 2 octagons come together; *ch 2, sk 2 sts on round 2, sc in next st on insert motif, ch 5, sk 2 sts**, sc in next st; rep from * around, ending last rep at **; join with sl st in first sc—8 sc, 4 ch-5 sps, 4 joined corners. Fasten off.

EDGING

Rnd 1: Join A with sc in any st, sc in every st and ch-1 sp around; join with sl st in first sc—892 sc. Fasten off.

finishing

Weave in all ends.

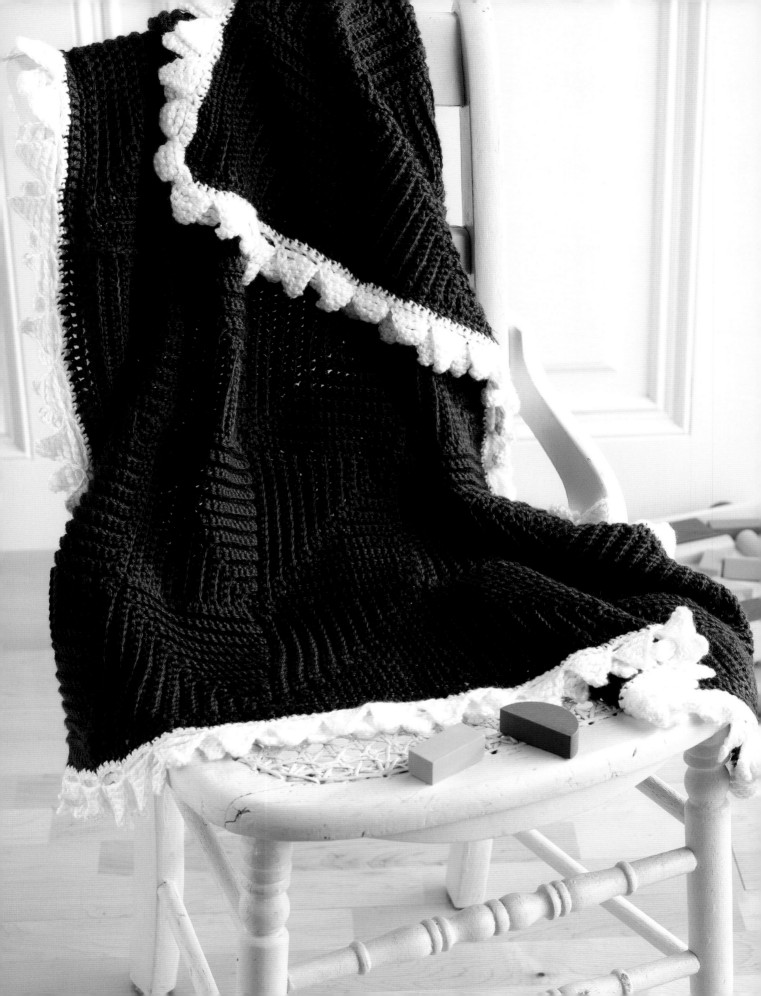

SHARK HUNTER
blanket

DESIGNED BY KRISTIN OMDAHL

What little boy (or girl) wouldn't love to have a blanket with shark teeth for the border? The blanket tiles are easy to crochet and make a soothing, dense fabric. The edging is worked twice, once in the front loops of the blanket's border and once in the back loops, with the two rows of toothy edging offset by half a repeat.

FINISHED SIZE
38" (96.5 cm) square.

YARN
Worsted weight (#4 Medium).

SHOWN HERE: Caron Simply Soft (100% acrylic; 315 yd [288 m]/6 oz [170 g]): #9711 dark country blue (MC), 4 skeins; #9701 white (CC), 1 skein.

HOOK
H/8 (5 mm) or size needed to obtain gauge.

NOTIONS
Tapestry needle for weaving in ends; straight pins for blocking.

GAUGE
1 motif = 5½" (14 cm) square.

NOTE
✣ Use MC for all motifs. CC will be used for Edging.

shark hunter motif

Refer to Stitch Diagram A at right for assistance.

MOTIF 1A

Row 1: Work 41 fsc.

Row 2: Ch 1, *sc-blo in ea of next 19 sts*, sc3tog-blo, rep from * to * once, turn—39 sts.

Row 3: Ch 1, *sc-blo in ea of next 18 sts*, sc3tog-blo, rep from * to * once, turn—37 sts.

Row 4: Ch 1, *sc-blo in ea of next 17 sts*, sc3tog-blo, rep from * to * once, turn—35 sts.

Rows 5–20: Cont in est patt until 3 sts rem.

Row 21 (last row): Ch 1, sc3tog-blo.

MOTIF 1B

Row 1: Ch 1, work 20 sc evenly along ends of rows on previous square, work 21 fsc—41 sts.

Rows 2–21: Rep Rows 2–21 of Motif 1A.

MOTIF 1C

Rep Motif 1B.

MOTIF 2A

Row 1: Loosely ch 21, sc in 2nd ch from hook and in ea ch across, work 20 sc evenly along ends of rows of previous square—41 sts.

Rows 2–21: Rep Rows 2–21 of Motif 1A.

MOTIF 2B

Row 1: Ch 1, work 20 sc evenly along ends of rows on previous square, work 21 sc spaced evenly across Motif 1B—41 sts.

Rows 2–21: Rep Rows 2–21 of Motif 1A.

MOTIF 2C

Rep Motif 2B.

MOTIF 3A

Rep Motif 2A.

MOTIF 3B

Rep Motif 2B.

MOTIF 3C

Rep Motif 2B. Fasten off.

shark hunter blanket

Refer to Stitch Diagram B on page 68 for assistance. Shark Hunter Motif instructions are at left.

MOTIF 1

Row 1: Work 41 fsc.

Row 2: Ch 1, *sc-blo in ea of next 19 sts*, sc3tog-blo, rep from * to * once, turn—39 sts.

Row 3: Ch 1, *sc-blo in ea of next 18 sts*, sc3tog-blo, rep from * to * once, turn—37 sts.

Row 4: Ch 1, *sc-blo in ea of next 17 sts*, sc3tog-blo, rep from * to * once, turn—35 sts.

Rows 5–20: Cont in est patt until 3 sts rem.

Row 21 (last row): Ch 1, sc3tog-blo. Do not fasten off.

MOTIF 2

Row 1: Ch 1, work 20 sc evenly along ends of rows on previous square, work 21 fsc—41 sts.

Rows 2–21: Rep Rows 2–21 of Motif 1.

MOTIFS 3–6

Rep Motif 2.

MOTIF 7

Row 1: Loosely ch 21, sc in 2nd ch from hook and in ea ch across, work 20 sc evenly along ends of rows of previous square—41 sts.

Rows 2–22: Rep Rows 2–22 of Motif 1.

MOTIF 8

Row 1: Ch 1, work 20 sc evenly along ends of rows on previous square, work 21 sc evenly spaced across next square in row 1, turn—41 sts.

MOTIFS 9–12

Rep Motif 8.

MOTIFS 13–18

Rep Motifs 7–12.

MOTIFS 19–24

Rep Motifs 7–12.

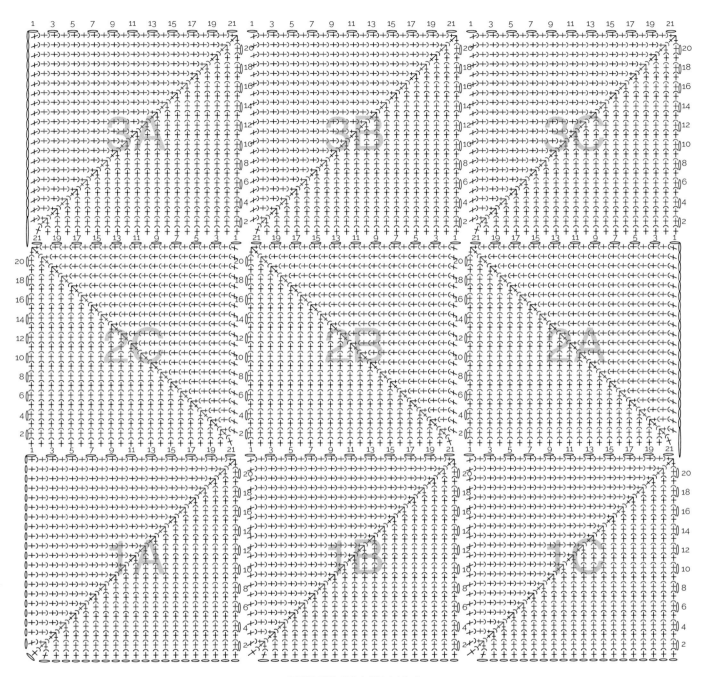

STITCH DIAGRAM A

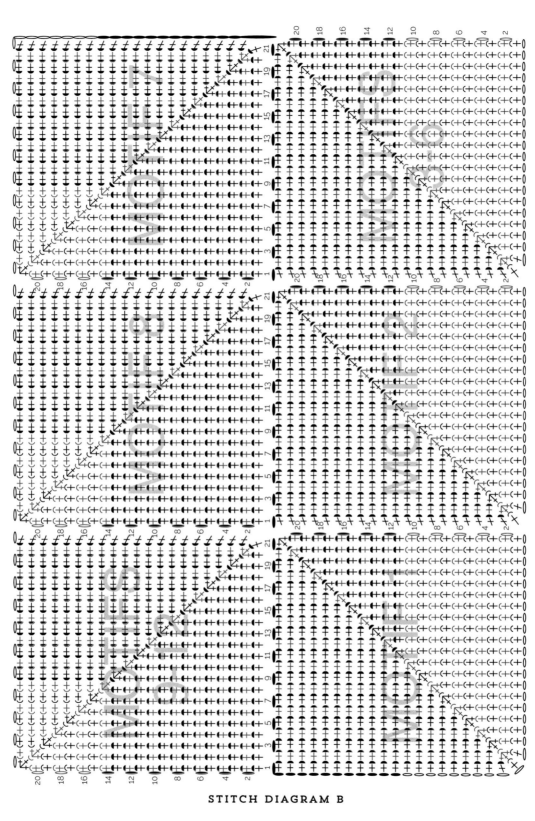

STITCH DIAGRAM B

MOTIFS 25–30

Rep Motifs 7–12.

MOTIFS 31–36

Rep Motifs 7–12.

Do not fasten off.

EDGING

Rnd 1: With MC, work 1 rnd of dc around entire perimeter of blanket, working 20 dc evenly across ea square, and 5 dc in ea of the 4 blanket corners—50 dc.

Fasten off.

Rnd 2A: With CC, join with sl st to back loop of any st. Ch 1, sc-blo in ea st around, sl st to join to first st at beg of rnd.

NOTE: Edging is worked twice, once in back loop (rnds marked A) and once in front loop (rnds marked B) of Rnd 1 of Edging.

Rnd 3A: *Ch 7, sc in 2nd ch from hook, hdc in next ch, dc in next ch, tr in next ch, dtr in ea

of next 2 chs, sk next 4 sts on Rnd 2A, sl st in next st on Rnd 2A. Rep from * around. Fasten off.

Rnd 2B: With CC, sk front loop of st joined at beg of Rnd 2A and sk next 2 front loops. Join with sl st in front loop of next st on Rnd 1. Ch 1, sc-flo in ea st around, sl st to join first st at beg of rnd.

NOTE: The location of the beginning of Rnd 2B is changed from Rnd 2A so the shark teeth are offset to look more like the layers of teeth on a real shark jaw!

Rnd 3B: Rep Rnd 3A.

Fasten off.

finishing

Wet-block to finished measurements, pinning teeth to dry flat. Weave in ends.

CHEVRON
bedspread

DESIGNED BY KATHIE ENG

Zigzags are perennial favorites with crocheters. This bed-sized blanket stitched in a soothing woodland palette features chevron stripes of varying widths to keep things interesting. Feel free to design a different color palette to match your boudoir!

FINISHED SIZE

54" × 80" (137 x 203 cm).

YARN

Worsted weight (#4 Medium).

SHOWN HERE: Berroco Comfort (50% superfine nylon/50% superfine acrylic, 210 yd [193 m]/3½ oz [100 g]), in #9767 marum (A), #9701 ivory (B), #9716 chambray (C), 3 skeins each; #9766 sable (D), #9761 lovage (E), #9744 teal (F), #9769 petunia (G), 2 skeins each; #9780 dried plum (H), #9747 cadet (I), #9763 navy blue (J), #9720 hummus (K), #9757 lillet (L), 1 skein each.

HOOK

Size J/10 (6 mm), or size needed to obtain gauge.

NOTIONS

Tapestry needle.

GAUGE

7¼ sts and 7 rows = 2" (5 cm) in chevron patt. *Take time to check your gauge.*

NOTES

✦ When changing color, always join new color beg in first ch-1 sp of right side row by drawing up a loop in ch-1 sp and ch 1.

bedspread

Beg in stripe color sequence (see Stitch Guide) with color A, ch 282.

Row 1 (RS): *Working in back loops of foundation ch,* sc in 2nd ch from hook, [ch 1, skip 1 ch, sc in next ch] 7 times, ch 1, skip 1 ch, (sc, ch 2, sc) in next ch, *[ch 1, skip 1 ch, sc in next ch] 7 times, skip next 2 chs, sc in next ch, [ch 1, skip 1 ch, sc in next ch] 6 times, ch 1, skip 1 ch, (sc, ch 2, sc) in next ch; rep from * across ending with [ch 1, skip 1 ch, sc in next ch] 8 times, ch 1, turn.

Row 2: Skip first sc, sc in next ch-1 sp, [ch 1, skip next sc, sc in next ch-1 sp] 7 times, ch 1, skip next sc, (sc, ch 2, sc) in next ch-2 sp, *[ch 1, skip next sc, sc in next ch-1 sp] 7 times, skip next 2 sc, sc in next ch-1 sp, [ch 1, skip next sc, sc in next ch-1 sp] 6 times, ch 1, skip next sc, (sc, ch 2, sc) in next ch-2 sp; rep from * across ending with [ch 1, skip next sc, sc in next ch-1 sp] 8 times, ch 1, turn.

Rows 3–12: Rep Row 2, fasten off color A.

Row 13 (RS): Join color B as noted above and rep Row 2.

Cont to work rem rows in established chevron patt, completing stripe sequence indicated above, fasten off in last row.

finishing

BORDER

With RS facing, join color G, at bottom corner of fnd ch at right-hand edge, draw up a loop through 2 loops. Beg edging from bottom, up along side as foll:

Rnd 1 (RS)—Right Side Edge: Ch 3, sl st in same ch, *ch 3, skip 1 row, sl st in end of next row; rep from * across to top ending at next-to-last row, ch 3, skip next-to-last row, (sl st, ch 3, sl st) in corner sc at end of last row, rotate work 90 degrees right, to work along top edge.

Rnd 1 (RS)—Top Edge: Ch 2, sl st in next ch-1 sp, [ch 2, skip next sc, sl st in next ch-1 sp] 7 times, ch 2, skip next sc, (sl st, ch 3, sl st) in next ch-2 sp, *[ch 2, skip next sc, sl st in next ch-1 sp] 7 times, ch 1, skip 2 sc, sl st in next ch-1 sp, [ch 2, skip next sc, sl st in next ch-1 sp] 6 times, ch 2, skip next sc, (sl st, ch 3, sl st) in next ch-2 sp; rep from * along top edge,

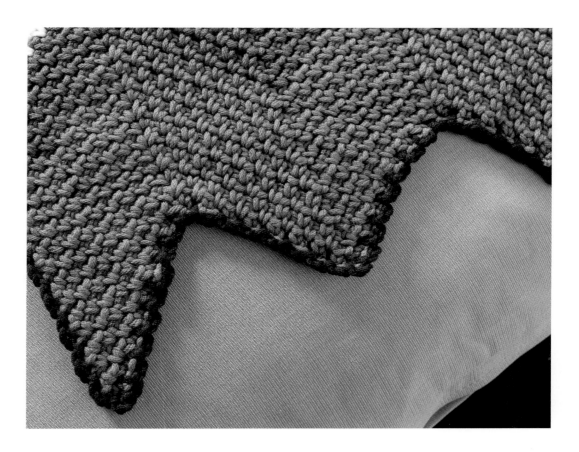

One way to plan harmonious color placement is to use symmetry. In this blanket, the stripes are arranged in a mirror-image sequence from the center out, a great technique for helping many-hued projects to look less busy. **—KATHIE ENG**

ending last rep with [ch 2, skip next sc, sl st in next ch-1 sp] 8 times, rotate work 90 degrees to work along side edge.

Rnd 1 (RS)—Left Side Edge: Ch 2, (sl st, ch 3, sl st) in last sc, *ch 3, skip 1 row, sl st in end of next row; rep from * along side edge to next-to-last row, ch 3, skip next row, (sl st, ch 3, sl st) through 2 loops of bottom corner ch, rotate work 90 degrees to work along bottom edge.

Rnd 1 (RS)—Bottom Edge: [Ch 2, skip next ch, sl st in next ch-1 sp] 8 times, *ch 2, skip next ch, sl st in next ch-1 sp, [ch 2, skip next ch, sl st in next ch-1 sp] 6 times, ch 2, skip next ch, (sl st, ch 3, sl st) in next ch-2 sp, [ch 2, skip next ch, sl st in next ch-1 sp] 7 times; rep from * along bottom edge, ending last with [ch 2, skip next ch, sl st in next ch-1 sp] 7 times, ch 2, skip next ch, sl st in beg sl st. Fasten off. Weave in ends to WS.

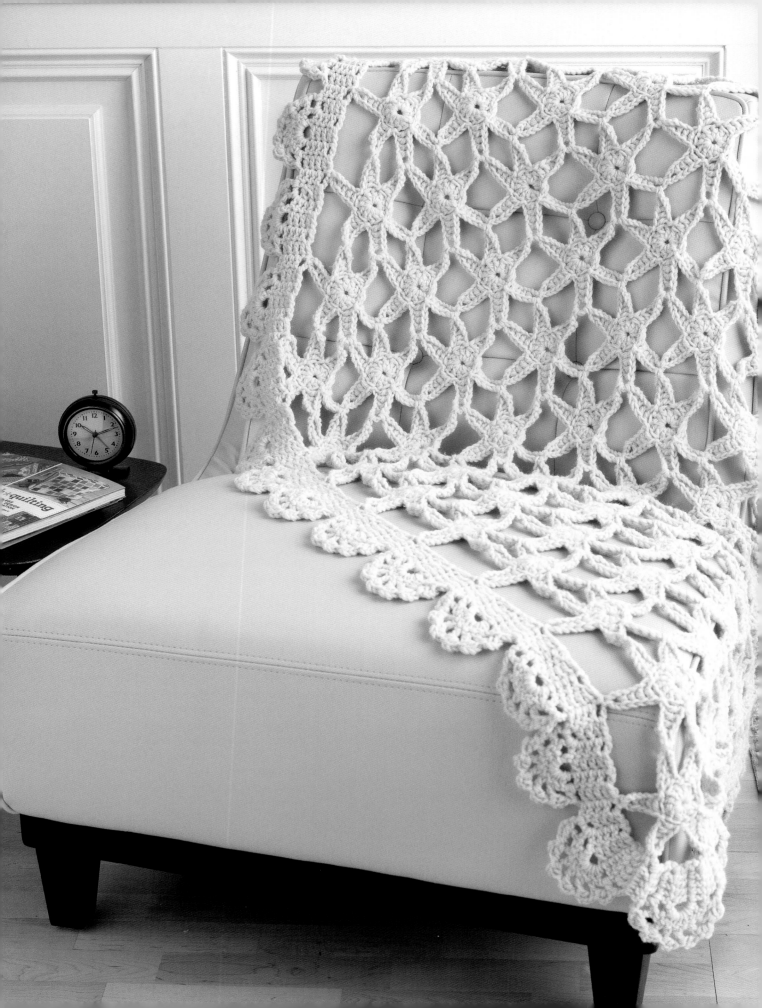

STARFISH
blanket

DESIGNED BY **KRISTIN OMDAHL**

This blanket has an unusual construction. Instead of working row after row of the same number of motifs, this blanket begins with one motif in the first row, increasing by one motif per row until the desired width is achieved, then decreasing by one motif per row for the second half of the blanket. The wide-scallop edging is worked in rows sideways from the edge of the blanket. The result is a uniquely shaped throw, with a fun aquatic theme—ideal for brightening up a child's bedroom.

FINISHED SIZE
46" wide x 71" long
(117 x 180 cm).

YARN
Worsted weight (#4 Medium).

SHOWN HERE: Lion Brand Pound of Love (100% premium acrylic; 1,020 yd [932 m]/16 oz [448 g]): 156 pastel green, 2 balls.

HOOK
K/10.5 (6.5 mm) or size needed to obtain gauge.

NOTIONS
Tapestry needle for weaving in ends.

GAUGE
With 2 strands held together, 12 sts and 6 rows dc = 4" (10 cm); 1 starfish motif = 5" (12.5 cm) in diameter.

NOTE
✦ Work with 2 strands of yarn held together as one throughout.

✦ Blanket is made in a diamond shape, beginning with 1 motif in row 1, increasing 1 motif in each row through row 9, then decrease one motif in each row until 1 motif remains in row 17.

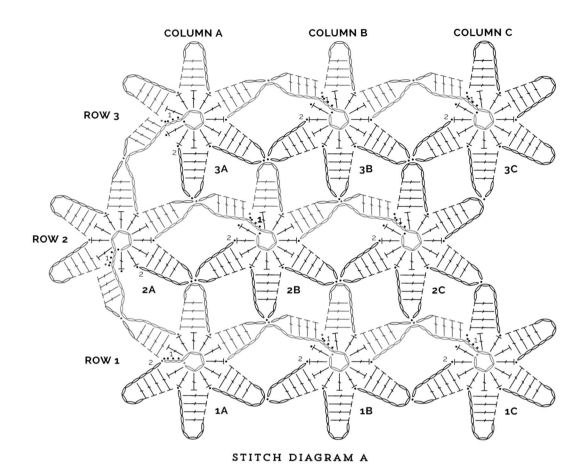

STITCH DIAGRAM A

starfish motif

Refer to Stitch Diagram A for assistance.

MOTIF 1A

Rnd 1: Ch 5 + 3 = 8, sl st in 5th ch from hook to join ring. Sl st in ea of next 3 chs (counts as dc), 11 dc in ring. Sl st to top of ch-3 at beg of rnd to join.

Rnd 2: *Ch 9, dc in 6th ch from hook, dc in ea of next 3 chs, sk next dc in Rnd 1, sl st in next dc. Rep from * twice.

MOTIF 1B

Rnd 1: Ch 5 + 3 + 4 + 9 = 21, sl st in 5th ch from hook to form ring, sl st in ea of next 3 chs (counts as dc), 11 dc in ring. Sl st to top of ch-3 at beg of rnd to join.

Rnd 2: Sl st in ea of next 2 dc, ch 6, sl st in ch-5 sp on adjacent motif, ch 2, sk last 4 chs made, dc in ea of next 4 chs, sk next dc in Rnd 1, sl st in next dc. *Ch 9, dc in 6th ch from hook, dc in ea of next 3 chs, sk next dc in Rnd 1, sl st in next dc. Rep from * once.

MOTIF 1C

Rnd 1: Rep Rnd 1 of Motif 1B.

Rnd 2: Sl st in ea of next 2 dc, ch 6, sl st in ch-5 sp on adjacent motif, ch 2, sk last 4 chs made, dc in ea of next 4 chs, sk next dc, sl st in next dc. *Ch 9, dc in 6th ch from hook, dc in ea of next 3 chs, sk next st in Rnd 1, sl st in next st. Rep from * 3 times.

Working across incomplete motifs in row 1, *dc in ea of next 4 beg chs, ch 2, sk next 2 chs, sl st in next ch, ch 2, sk next 2 ch, dc in ea of next 4 chs, sk next dc on next motif, sl st in next dc. Ch 9, dc in 6th ch from hook, dc in ea of next 4 chs, sk next dc on Rnd 1, sl st in next dc. Rep from * once.

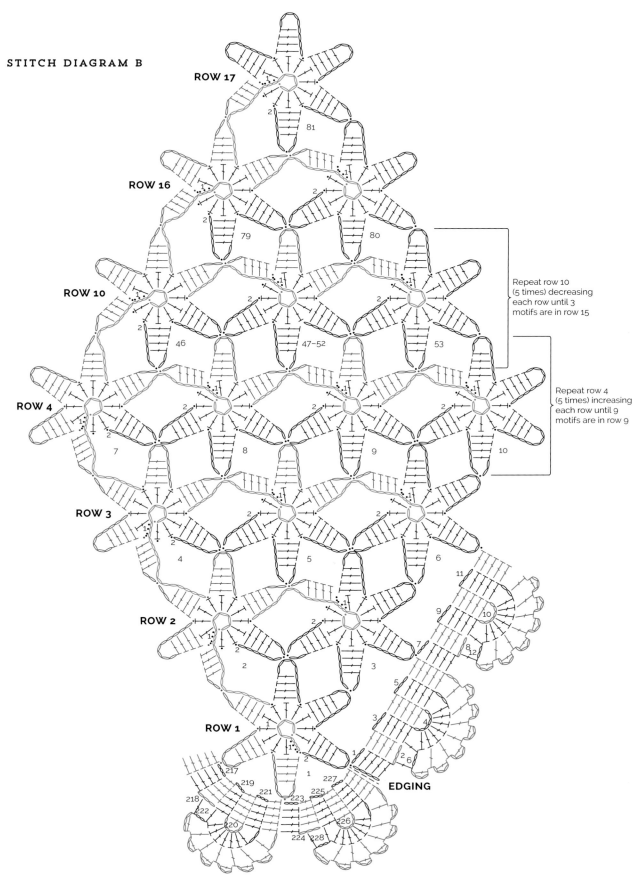

STITCH DIAGRAM B

ROW 17

81

ROW 16

79 80

ROW 10

46 47–52 53

Repeat row 10
(5 times) decreasing
each row until 3
motifs are in row 15

ROW 4

7 8 9 10

Repeat row 4
(5 times) increasing
each row until 9
motifs are in row 9

ROW 3

4 5 6

11

9 10

ROW 2

7

8 12

2 3

5

ROW 1

3 4

1 2 6

217 227 EDGING

219 225

218 221 223

222 220 224 228 226

MOTIF 2A

Rnd 1: Rep Rnd 1 of Motif 1B.

Rnd 2: Sl st in ea of next 2 dc, *ch 6, sl st in ch-5 sp on adjacent motif, ch 2, sk last 4 chs made, dc in ea of next 4 chs, sk next dc in Rnd 1, sl st in next dc.

MOTIF 2B

Rnd 1: Rep Rnd 1 of Motif 1B.

Rnd 2: Sl st in ea of next 2 dc, *ch 6, sl st in ch-5 sp on adjacent motif, ch 2, sk last 4 chs made, dc in ea of next 4 chs, sk next dc in Rnd 1, sl st in next dc. Rep from * twice.

MOTIF 2C

Rnd 1: Rep Rnd 1 of Motif 1B.

Rnd 2: Sl st in ea of next 2 dc, *ch 6, sl st in ch-5 sp on adjacent motif, ch 2, sk last 4 chs made, dc in ea of next 4 chs, sk next dc, sl st in next dc. Rep from * twice. **Ch 9, dc in 6th ch from hook, dc in ea of next 3 chs, sk next st in Rnd 1, sl st in next dc. Rep from ** once.

Working across incomplete motifs in row 2, dc in ea of next 4 beg chs, ch 2, sk next 2 ch, sl st in next ch, ch 2, sk next 2 ch, dc in ea of next 4 ch, sk next dc on next motif, sl st in next dc. Ch 9, dc in 6th ch from hook, dc in ea of next 3 chs, sk next dc in Rnd 1, sl st in next dc, dc in ea of next 4 beg chs, ch 2, sk next 2 ch, sl st in next ch, ch 2, sk next 2 ch, dc in ea of next 4 ch, sk next dc on next motif, sl st in next dc.

MOTIF 3A

Rnd 1: Rep Rnd 1 of Motif 1B.

Rnd 2: Sl st in ea of next 2 dc, *ch 6, sl st in ch-5 sp on adjacent motif, ch 2, sk last 4 chs made, dc in ea of next 4 chs, sk next dc in Rnd 1, sl st in next dc. Rep from * once.

MOTIF 3B

Rep Motif 2B.

MOTIF 3C

Rnd 1: Rep Rnd 1 of Motif 1B.

Rnd 2: Sl st in ea of next 2 dc, *ch 6, sl st in ch-5 sp on adjacent motif, ch 2, sk last 4 chs made, dc in ea of next 4 chs, sk next dc in Rnd 1, sl st in next dc. Rep from * once. **Ch 9, dc in 6th ch from hook, dc in ea of next 3 chs, sk next dc in Rnd 1, sl st in next dc. Rep from ** twice.

Working across incomplete motifs of row 3, *dc in ea of next 4 beg chs, ch 2, sk next 2 ch, sl st in next ch, ch 2, sk next 2 ch, dc in ea of next 4 ch, sk next dc on next motif, sl st in next dc. Ch 9, dc in 6th ch from hook, dc in ea of next 3 chs, sk next dc in Rnd 1, sl st in next dc. Rep from * once. Ch 9, dc in 6th ch from hook, dc in ea of next 3 chs, sk next st on Rnd 1, sl st in next st.

Working along side edge of incomplete motifs in column A, dc in ea of next 4 beg chs, ch 2, sk next 2 ch, sl st in next ch, ch 2, sk next 2 ch, dc in ea of next 4 ch, sk next dc on next motif, sl st in next dc. [Ch 9, dc in 6th ch from hook, dc in ea of next 4 chs, sk next dc in Rnd 1, sl st in next dc] twice, dc in ea of next 4 beg chs, ch 2, sk next 2 ch, sl st in next ch, ch 2, sk next 2 ch, dc in ea of next 4 ch, sk next dc on next motif, sl st in next dc. Fasten off.

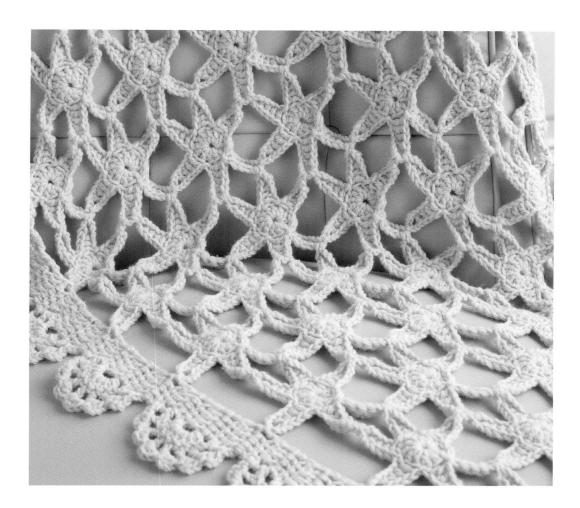

starfish blanket

Refer to Stitch Diagram B on page 77 and the Construction Diagram on page 80 for assistance. Starfish Motif instructions begin on page 76.

MOTIF 1

Rnd 1: Ch 5 + 3 = 8, sl st in 5th ch from hook to join ring. Sl st in ea of next 3 chs (counts as dc), 11 dc in ring. Sl st to top of ch-3 at beg of rnd to join.

Rnd 2: *Ch 9, dc in 6th ch from hook, dc in ea of next 3 chs, sk next st on Rnd 1, sl st in next st. Rep from * twice—3 petals made.

MOTIF 2

Rnd 1: Ch 5 + 3 + 4 + 9 = 21, sl st in 5th ch from hook to join ring. Sl st in ea of next 3 chs (counts as dc), 11 dc in ring. Sl st to top of ch-3 at beg of rnd to join.

Rnd 2: Sl st in ea of next 2 dc, ch 6, sl st in ch-5 sp of adjacent motif, ch 2, sk last 4 chs made, dc in ea of next 4 chs, sk next dc in Rnd 1, sl st in next dc.

MOTIF 3

Rnd 1: Rep Rnd 1 of Motif 2.

Rnd 2: Sl st in ea of next 2 dc, [ch 6, sl st in ch-5 sp on adjacent flower's petal, ch 2, sk last 4 chs made, dc in ea of next 4 chs, sk next dc in Rnd 1, sl st in next dc] twice, *ch 9, dc in 6th ch from hook, dc in ea of next 3 chs, sk next dc in Rnd 1, sl st in next dc. Rep from * twice.

Completion Row 1: Working across incomplete motifs in row 2, dc in ea of next 4 beg chs, ch 2, sk next 2 chs, sl st in next ch, ch 2, sk next 2 chs, dc in ea of next 4 beg chs, sk next dc on next motif, sl st in next dc. Ch 9, dc in 6th ch from hook, dc in ea of next 3 chs, sk next dc on Rnd 1, sl st in next dc.

MOTIF 4

Rep Motif 2.

MOTIF 5

Rnd 1: Rep Rnd 1 of Motif 2.

Rnd 2: Sl st in ea of next 2 dc. [Ch 6, sl st in ch-5 sp on adjacent motif, ch 2, sk last 4 chs made, dc in ea of next 4 chs, sk next dc, sl st in next dc] 3 times.

MOTIF 6

Rep Motif 3.

Completion Row 2: Working across incomplete motifs in row 3, *dc in ea of next 4 beg chs, ch 2, sk next 2 chs, sl st in next ch, ch 2, sk next 2 chs, dc in ea of next 4 chs, sk next dc on next motif, sl st in next dc*. Ch 9, dc in 6th ch from hook, dc in ea of next 3 chs, sk next dc on Rnd 1, sl st in next dc. Rep from * to * once.

MOTIF 7

Rep Motif 2.

MOTIFS 8–9

Rep Motif 5.

MOTIF 10

Rep Motif 3.

Completion Row 3: Working across incomplete motifs in row, dc in ea of next 4 beg chs, ch 2, sk next 2 ch, *(sl st in next ch, ch 2, sk next 2 ch, dc in ea of next 4 chs, sk next dc on next motif, sl st in next dc*, ch 9, dc in 6th ch from hook, dc in ea of next 3 chs, sk next dc on Rnd 1, sl st in next dc, dc in ea of next 4 beg chs, ch 2, sk next 2 chs) across to last motif. Rep from * to * once.

MOTIF 11

Rep Motif 2.

MOTIFS 12–14

Rep Motif 5.

MOTIF 15

Rep Motif 3.

Rep Completion Row 3.

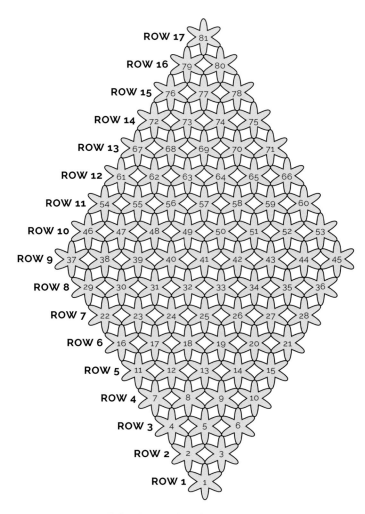

CONSTRUCTION DIAGRAM

MOTIF 16

Rep Motif 2.

MOTIFS 17–20

Rep Motif 5.

MOTIF 21

Rep Motif 6.

Rep Completion Row 3.

MOTIF 22

Rep Motif 2.

MOTIFS 23–27

Rep Motif 5.

MOTIF 28

Rep Motif 3.

Rep Completion Row 3.

MOTIF 29

Rep Motif 2.

MOTIFS 30–35

Rep Motif 5.

MOTIF 36

Rep Motif 3.

Rep Completion Row 3.

MOTIF 37

Rep Motif 2.

MOTIFS 38–44

Rep Motif 5.

MOTIF 45

Rep Motif 3.

Completion Row 4: Working across incomplete motifs in row, dc in ea of next 4 beg chs, ch 2, sk next 2 ch, (sl st in next ch, ch 2, sk next 2 ch, dc in ea of next 4 chs, sk next dc on next motif, sl st in next dc, ch 9, dc in 6th ch from hook, dc in ea of next 4 chs, sk next dc on Rnd 1, sl st in next dc, dc in ea of next 4 beg chs, ch 2, sk next 2 chs) across to last motif, sl st in next ch, ch 2, sk next 2 ch, dc in ea of next 4 chs, sk next dc on next motif, sl st in next dc.

MOTIF 46

Rnd 1: Rep Rnd 1 of Motif 2.

Rnd 2: Sl st in ea of next 2 dc, [ch 6, sl st in ch-5 sp of adjacent motif, ch 2, sk last 4 chs made, dc in ea of next 4 chs, sk next dc in Rnd 1, sl st in next dc] twice.

MOTIFS 47–52

Rep Motif 5.

MOTIF 53

Rnd 1: Rep Rnd 1 of Motif 2.

Rnd 2: Sl st in ea of next 2 dc, [ch 6, sl st in ch-5 sp on adjacent flower's petal, ch 2, sk last 4 chs made, dc in ea of next 4 chs, sk next dc in Rnd 1, sl st in next dc] 3 times. **Ch 9, dc in 6th ch from hook, dc in ea of next 3 chs, sk next dc in Rnd 1, sl st in next dc. Rep from ** once.

Rep Completion Row 4.

MOTIF 54

Rep Motif 46.

MOTIFS 55–59

Rep Motif 5.

MOTIF 60

Rep Motif 53.

Rep Completion Row 4.

MOTIF 61

Rep Motif 46.

MOTIFS 62–65

Rep Motif 5.

MOTIF 66

Rep Motif 53.

Rep Completion Row 4.

MOTIF 67

Rep Motif 46.

MOTIFS 68–70

Rep Motif 5.

MOTIF 71

Rep Motif 53.

Rep Completion Row 4.

MOTIF 72

Rep Motif 46.

MOTIFS 73–74

Rep Motif 5.

MOTIF 75

Rep Motif 53.

Rep Completion Row 4.

MOTIF 76

Rep Motif 46.

MOTIF 77

Rep Motif 5.

MOTIF 78

Rep Motif 53.

Rep Completion Row 4.

MOTIF 79

Rep Motif 46.

MOTIF 80

Rep Motif 53.

Completion Row 5: Working across incomplete motifs in row, dc in ea of next 4 beg chs, ch 2, sk next 2 chs, sl st in next ch, ch 2, sk next 2 chs, dc in ea of next 4 beg chs, sk next dc on next motif, sl st in next dc.

MOTIF 81

Rnd 1: Rep Rnd 1 of Motif 2.

Rnd 2: Sl st in ea of next 2 dc, [ch 6, sl st in ch-5 sp on adjacent flower's petal, ch 2, sk last 4 chs made, dc in ea of next 4 chs, sk next dc in Rnd 1, sl st in next dc] twice. *Ch 9, dc in 6th ch from hook, dc in ea of next 3 chs, sk next dc in Rnd 1, sl st in next dc. Rep from * twice.

Working across side edge of blanket, dc in ea of next 4 beg chs, ch 2, sk next 2 chs, sl st in next ch, *ch 2, sk next 2 chs, dc in ea of next 4 chs, sk next dc in Rnd 1 of next motif, sl st in next dc, ch 9, dc in 6th ch from hook, dc in ea of next 3 chs, sk next dc in Rnd 1, sl st in next st, dc in ea of next 4 beg chs, ch 2, sk next 2 chs, sl st in next ch*. Rep from * to * 6 times to complete Motifs 76, 72, 67, 61, 54, and 46. Ch 2, sk next 2 chs, dc in ea of next 4 chs, sk next dc in Rnd 1 of next motif, sl st in next dc, [ch 9, dc in 6th ch from hook, dc in ea of next 3 chs, sk next dc in Rnd 1, sl st in next st] twice, dc in ea of next 4 beg chs, ch 2, sk next 2 chs, sl st in next ch. Rep from * to * 7 times to complete Motifs 29, 22, 16, 11, 7, 4, and 2. Ch 2, sk next 2 ch, dc in ea of next 4 beg chs, ch 2, sk next 2 chs, sl st in next dc, [ch 9, dc in 6th ch from hook, dc in ea of next 3 chs, sk next dc in Rnd 1, sl st in next st] twice, ending with last sl st in top of beg ch-3 in Motif 1. Fasten off.

edging

Ch 4, sl st in ch-5 sp at end of first petal of Motif 1, turn.

Row 1 (WS): Ch 3 (counts as dc here and throughout), dc in ea of next 4 ch of beg ch, turn—5 dc.

Rows 2–3: Ch 3, sk first dc, dc in ea dc across, turn—5 dc.

Row 4: Ch 6, dc in first dc, dc in ea dc across, turn—5 dc.

Row 5: Ch 3, sk first dc, dc in ea dc across, ch 2, 7 dc in next ch-6 sp, dc in side of st at end of Row 3, ch 2, dc in side of st at end of Row 2, turn.

Row 6: Ch 3, dc in 3rd ch from hook, sk next dc of 7 dcs in ch-6 sp, dc in next dc, [ch 3, dc in 3rd ch from hook, dc in next dc] 4 times, (ch 3, dc in 3rd ch from hook), sk next dc, dc in next ch-2 sp, ch 2, dc in ea of next 5 dc, sl st in ch-5 sp at tip of next petal along edge of blanket, turn.

Row 7: Ch 3, sk first dc, dc in ea dc across—5 dc.

Rows 8–229: Rep Rows 2–7 thirty-six times until you have worked the edging and joined it to all free petals around blanket, then work Rows 2–6 once more. Fasten off. Whipstitch last row to starting chain at beg of edging. Weave in ends.

Wet-block, pin to finished measurements, and let dry.

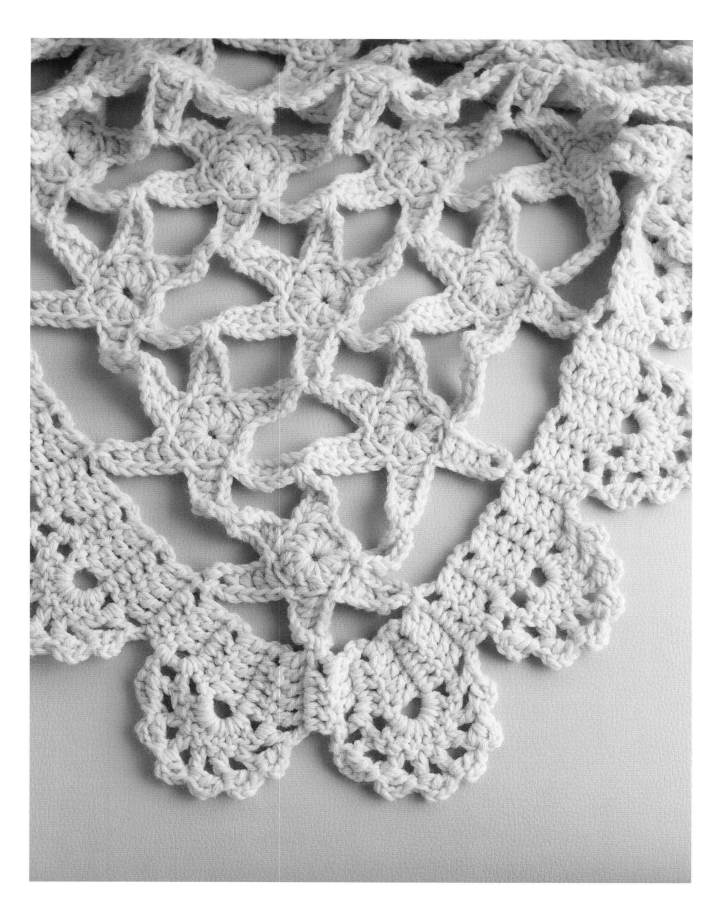

HIALEAH HONEY
blanket

DESIGNED BY **BONNIE BARKER**

Named for designer Bonnie Barker's Florida hometown, this is the first project in which she experimented with lighter weight yarns. She instantly became an enthusiastic believer. Not only does this yarn help keep down the bulkiness of the post stitches, but it also produces a beautiful drape to the finished project. Be sure to use a yarn that can easily be washed for your special little honey!

FINISHED SIZE

21½" × 23½" (54.6 × 59.7 cm), excluding edging.

YARN

DK weight (#3 Light).

SHOWN HERE: Caron Simply Soft Light (100% acrylic; 330 yd [302 m]/3 oz [85 g]): #0003 honey, 3 skeins.

HOOK

G/6 (4 mm) crochet hook.

GAUGE

24 sts = 4½" (11.4 cm) and 7 rows = 3" (7.6 cm) in Celtic Weave pattern (measure from back).

NOTE

✛ The double crochet stitches in between the Braided Cable and Celtic Weave stitches are worked in the top loops of the stitches, not as front posts. All other stitches are front or back post stitches.

As a blessed mommy of five children, I remember the joy of discovery in my little tykes' eyes as they experienced everything for the first time. I also have vague memories as a little girl of studying the patterns in my "blankie," which was a small, handmade, patchwork quilt—over and over again. This is why I design with a lot of interesting texture for baby's eyes. **—BONNIE BARKER**

blanket

Ch 106.

Row 1: Dc in the 4th ch from hook and in each ch across. Turn. (104 dc).

Row 2 (RS): Ch 3 (counts as 1st dc here and throughout). Dc in 2nd dc, *work BC over next 6 sts, dc in next 2 sts. Work CW over next 12 sts. Dc in next 2 sts. Work BC over next 6 sts; **dc in next 2 sts; work BC over next 6 sts; dc in next 2 sts; work CW over next 24 sts; dc in next 2 sts; work BC over next 6 sts; dc in next 2 sts. Rep * to ** once more. Dc in last 2 sts. Turn.

Row 3 (WS): Rep Row 2, working the WS version of the indicated st patterns.

Rows 4–53: Rep Rows 2 & 3 twenty-five times more, or to within 2" (5.1cm) of desired length.

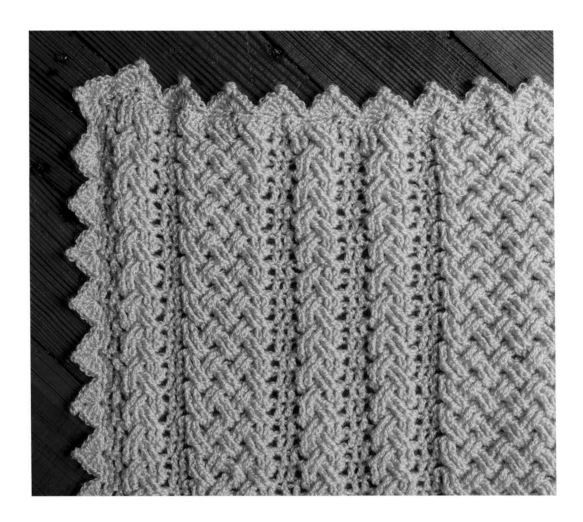

Row 54: Rep Row 2.

Row 55: Ch 3, bpdc in each post st and dc in each dc across. Turn.

BORDER

Rnd 1: Ch 1. *Sc in each st across row, ch 1, turn 90˚, sc in same sp (corner made). Sc evenly along row edges, ch 1, turn 90˚, rep from * around. Join with a sl st to 1st sc of row. Turn.

Rnd 2 (shell with picot): Ch 1, sc in 1st st, * sk 2 sts, [4 dc, ch 4, sl st in 1st ch (picot made), 4 dc] in next st, sk 2 sts, sc in next st. Rep from * around perimeter of blanket. You may need to adjust the number of sts skipped occasionally in order for the shells to appear uniform around the corners. End by joining with sl st to 1st sc of row. Finish off.

finishing
Weave in ends and block if needed.

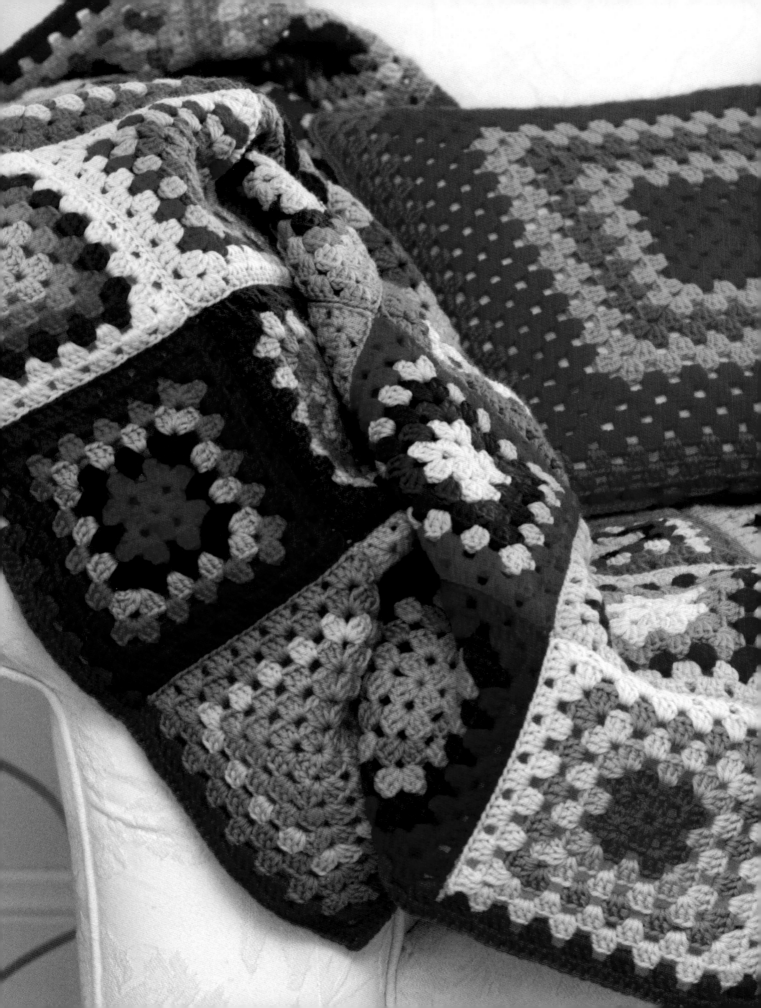

GRANNY
sofa blanket

DESIGNED BY **SARAH LONDON**

Boldly make a color impact with a sprightly granny-square blanket. This lively blanket will brighten any living room and fill it with sunshine even on the grayest of days. When the weather turns chilly, keep your blanket close at hand by draping it over the back of the sofa. A crocheted granny-square blanket will provide comfort and warmth on chilly winter evenings and will be loved by many generations.

FINISHED SIZE

As desired; each square measures 6" × 6" (15 × 15 cm).

YARN

Worsted weight (#4 Medium).

SHOWN HERE: Cascade 220 (100% Peruvian highland wool; 220 yd [201 m]/3½ oz [100 g]: random assortment of colors (small amounts are okay); each square uses about 38 yd (35 m) of yarn.

HOOK

U.S. size G/6 (4mm).

NOTIONS

Yarn needle.

GAUGE

Gauge is not important.

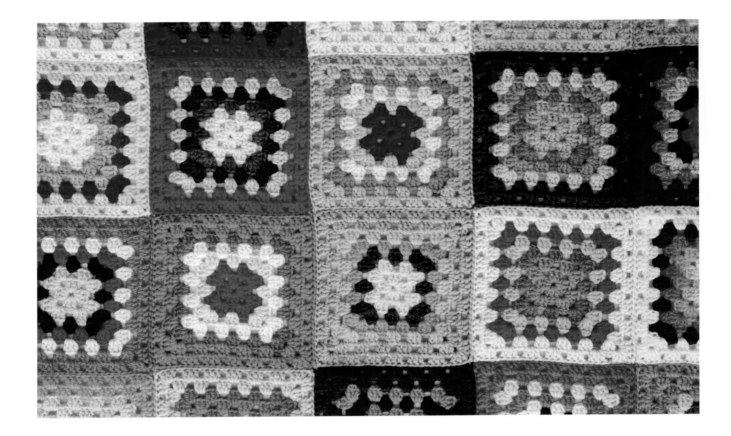

square

Make number desired.

With desired color, ch 5, join with a sl st to form a ring.

Rnd 1: Ch 3, work 2 dc into the ring, * ch 2, work 3 dc into the ring; rep from * twice more, ch 2, join with a sl st into top of beg ch-3. Sl st across the next 2 sts and into the corner sp.

Rnd 2: Ch 3, work (2 dc, ch 2, 3 dc) into corner sp, * ch 1, work (3 dc, ch 2, 3 dc) into next ch-2 corner sp; rep from * twice more, ch 1, join with a sl st into top of beg ch-3. Sl st across the next 2 sts and into the corner sp. Fasten off current color.

Rnd 3: Join new color into any ch-2 corner sp, ch 3, work (2 dc, ch 2, 3 dc) into corner sp, * ch 1, work 3 dc into ch-1 sp, ch 1, work (3 dc, ch 2, 3 dc) into next ch-2 corner sp; rep from * twice more, ch 1, work 3 dc into ch-1 sp, ch 1, join with a sl st into top of beg ch-3. Sl st across the next 2 sts and into the corner sp. Fasten off current color.

Rnd 4: Join new color into any ch-2 corner sp, ch 3, work (2 dc, ch 2, 3 dc) into corner sp, * ch 1, [work 3 dc into ch-1 sp, ch 1] twice, work (3 dc, ch 2, 3 dc) into next ch-2 corner sp; rep from * twice more, ch 1, [work 3 dc into ch-1 sp, ch 1] twice, join with a sl st into top of beg ch-3. Sl st across the next 2 sts and into the corner sp. Fasten off current color.

Rnd 5: Join new color into any ch-2 corner sp, ch 3, work (2 dc, ch 2, 3 dc) into corner sp, * ch 1, [work 3 dc into ch-1 sp, ch 1] 3 times, work (3 dc, ch 2, 3 dc) into next ch-2 corner sp; rep from * twice more, ch 1, [work 3 dc into ch-1 sp, ch 1] 3 times, join with a sl st into top of beg ch-3. Sl st across the next 2 sts and into the corner sp. Fasten off current color.

Rnd 6: Join new color into any ch-2 corner sp, ch 3, work (2 dc, ch 2, 3 dc) into corner sp, * ch 1, [work 3 dc into ch-1 sp, ch 1] 4 times, work (3 dc, ch 2, 3 dc) into next ch-2 corner sp; rep from * twice more, ch 1, [work 3 dc into ch-1 sp, ch 1] 4 times, join with a sl st into top of beg ch-3. Sl st across the next 2 sts and into the corner sp.

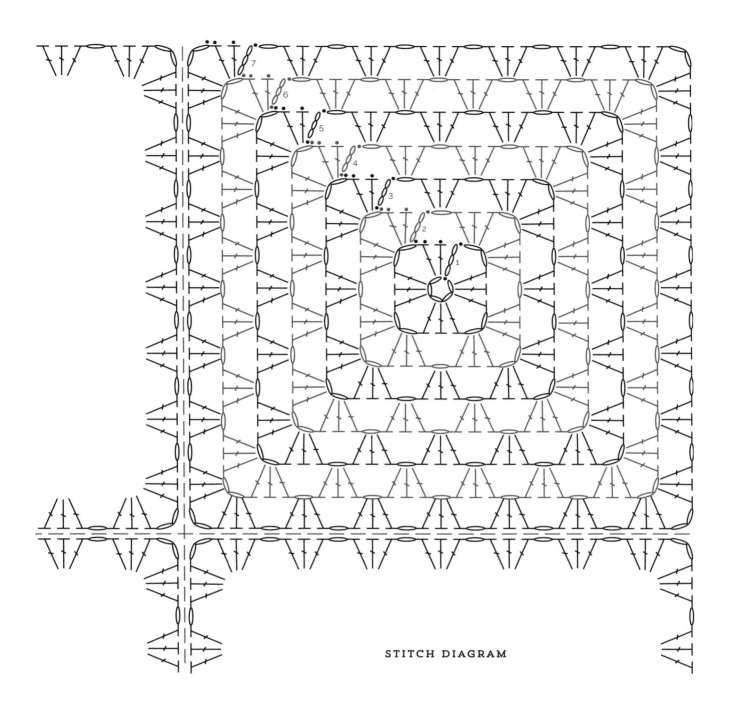

STITCH DIAGRAM

Rnd 7: Ch 3, work (2 dc, ch 2, 3 dc) into corner sp, * ch 1, [work 3 dc into ch-1 sp, ch 1] 5 times, work (3 dc, ch 2, 3 dc) into next ch-2 corner sp; rep from * twice more, ch 1, [work 3 dc into ch-1 sp, ch 1] 5 times, join with a sl st into top of beg ch-3. Sl st across the next 2 sts and into the corner sp. Fasten off current color.

finishing

Join squares using preferred method. Weave in ends. Block if desired.

My method for making a multicolored granny square blanket is simple—more is more. Collect as many colors as possible to create a captivating blanket saturated in color. I work in a somewhat production-line fashion on a blanket like this. First, I crochet the first two rounds for every square, incorporating every color from my collection of yarn. It's not necessary to overanalyze color components when making multicolored blankets; randomly chosen colors ignite their own special magic. Continue randomly adding colored rounds to each square. When I work, often the next color added will be the color closest to me. Have fun with color and you won't go wrong. **—SARAH LONDON**

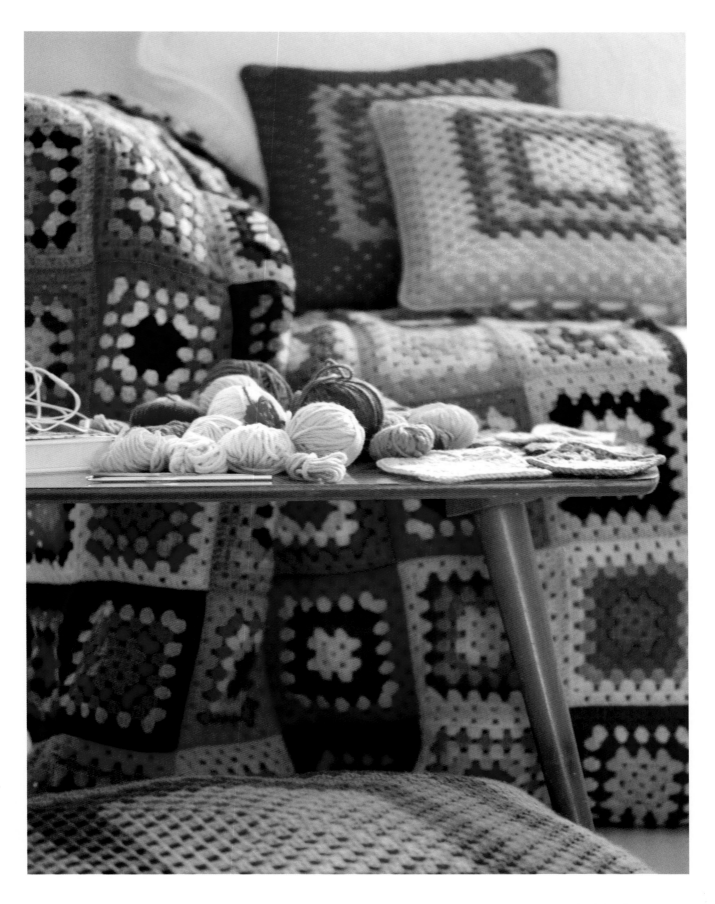

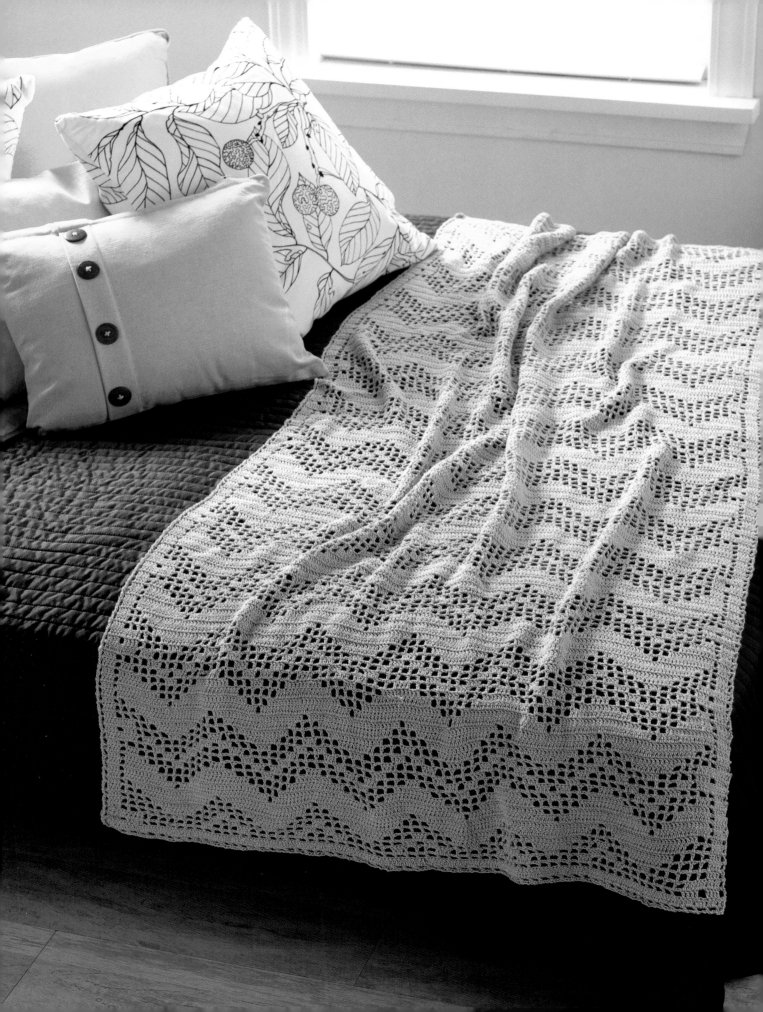

FILET ZIGS + ZAGS
blanket

DESIGNED BY **MARI LYNN PATRICK**

Filet crochet isn't just for flowers and lace! Worked in a chevron pattern, filet is thoroughly graphic and modern. This pattern is easy to alter to make it larger or smaller—or even to change it into a window curtain—for perfect custom results.

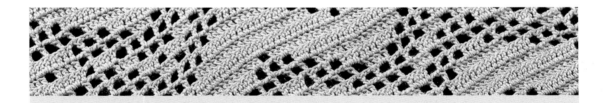

FINISHED SIZE
38" (96.5 cm) × 62" (157.5 cm), after blocking.

YARN
Sportweight (#2 Fine).

SHOWN HERE: Red Heart Luster Sheen (100% acrylic, 307 yd [281 m]/3½ oz [100 g]), in #0615 tea leaf, 6 skeins.

HOOK
Size E/4 (3.5 mm), or size needed to obtain gauge.

GAUGE
21 dc and 16 rows = 4" (10 cm) over dc patt st using size E/4 (3.5 mm) hook, before blocking. Take time to check your gauge.

NOTES
+ The chart for the curtain represents filet mesh crochet blocks combined with "dc filled" solid blocks.

+ To alter the width of the curtain (for 6" [15 cm] in width or 3" [7.5 cm] length), either add or subtract one patt rep and to alter the length, add or subtract one 12-row rep.

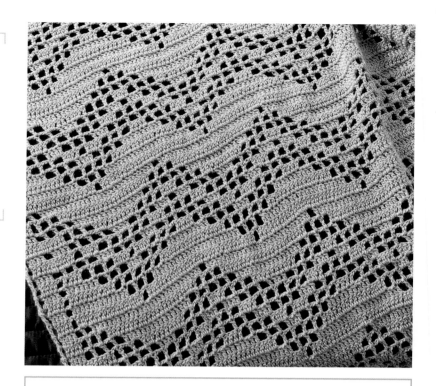

When it comes to color, sometimes less is more—and this piece proves it. The intricate pattern might get lost if worked in multiple colors or a variegated yarn, so to allow an openwork stitch like this to truly shine, stick with a single solid shade.

—MARI LYNN PATRICK

blanket

Ch 205 evenly.

Row 1: Dc in 7th ch from hook, *ch 2, skip 2 ch, dc in next ch; rep from * to end—67 mesh blocks, ch 5 (counts as dc and ch 2), turn.

Row 2: Dc in next dc, *2 dc in ch-2 sp, dc in next dc; rep from * to last mesh, dc ch 2, skip last 2 ch, dc in top of tch, ch 5 (counts as dc and ch 2), turn.

Row 3: Dc in next dc, (dc in each of next 2 dc, dc in next dc), (ch 2, skip 2 sts, dc in next dc), (dc in each of next 2 dc, dc in next dc), *(ch 2, skip 2 sts, dc in next dc); rep from * 59 times, (dc in each of next 2 dc, dc in next dc), (ch 2, skip 2 sts, dc in next dc), (dc in each of next 2 dc, dc in next dc), (ch 2, skip 2 chs, dc in next ch), ch 5 (counts as dc and ch 2), turn.

Rows 4–24: Cont to work even foll chart with ch 5 at beg of rows as established.

Rep Rows 13–24 (for the 12-row repeat) 11 times more with ch 5 at beg of rows as established.

Rows 25–32: Cont to work even foll chart with ch 5 at beg of rows as established.

Fasten off.

finishing

Weave in ends. Wet-block to measurements.

CHART KEY

☐ **Mesh Square**
= (ch 2, skip 2 sts, dc in next dc).

☒ **Solid Square**
= 2 dc in ch-2 sp (or dc in each 2 dc in row below), dc in next dc.

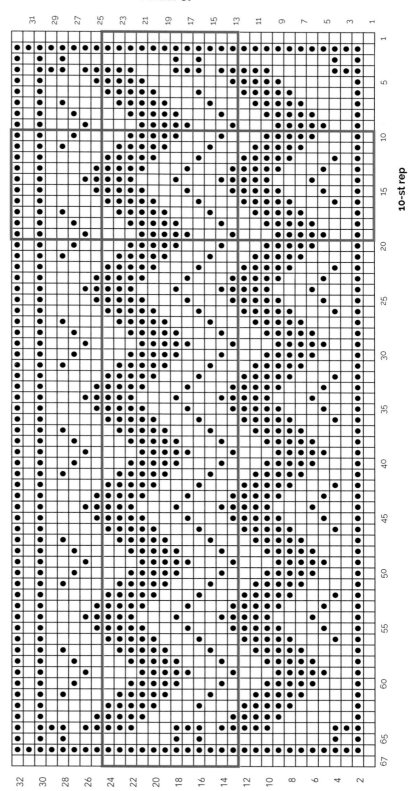

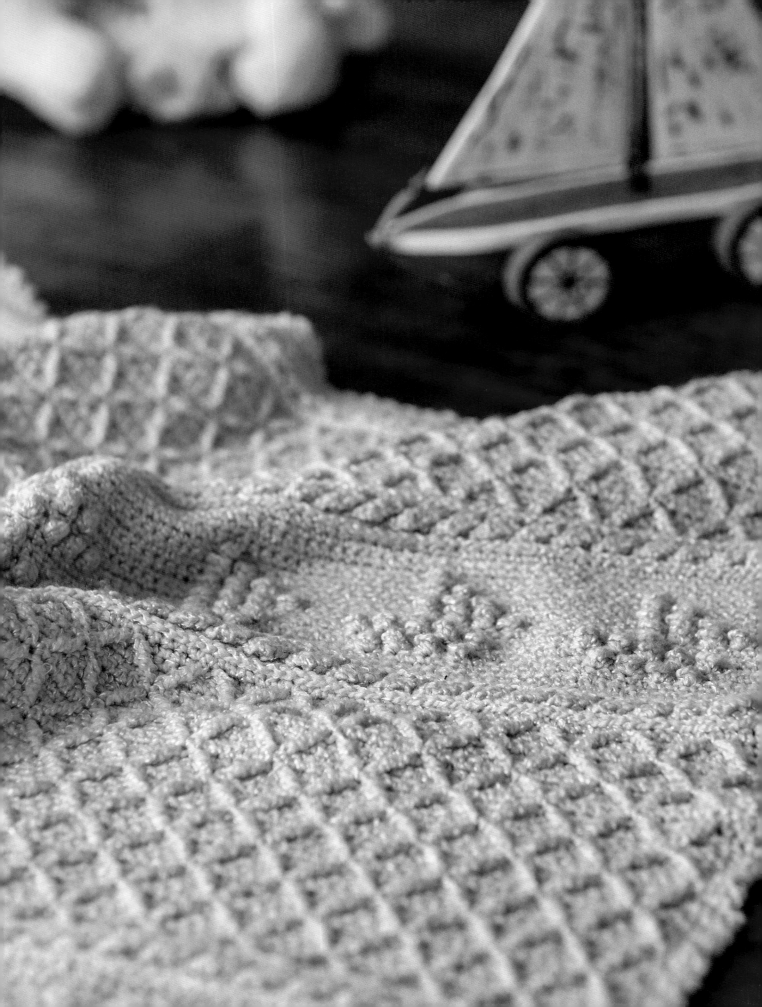

SAILBOATS
blanket

DESIGNED BY **BONNIE BARKER**

Here's a fun crochet project for that precious little one in your life! The textures of this nautical-themed blanket will not only be stimulating for baby to see, but also to touch. Be sure to use yarn than can handle the waves of the washing machine!

FINISHED SIZE
33" × 26" (83.8 cm × 66 cm), including edging.

YARN
DK weight (#3 Light).

SHOWN HERE: Bernat Baby Coordinates (75.2% acrylic, 22.2% rayon, 2.6% nylon; 388 yd [355 ml/5 oz [140 g]): #48128 soft blue, 5 skeins.

HOOKS
H/8 (5 mm) crochet hook.

G/6 (4 mm) crochet hook or one hook size smaller than gauge hook.

E/4 (3.5 mm) crochet hook or two hook sizes smaller than gauge hook.

GAUGE
11 sts = 2½" (6.4 cm) and 9 rows = 2" (5.1 cm) in sc.

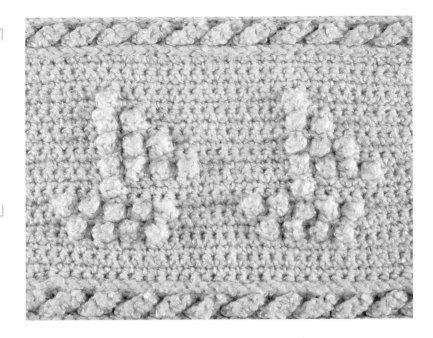

bottom panel

Using gauge hook, ch 135.

Row 1 (RS): Sc in 2nd ch from hook and in each ch across. Turn (134 sc).

Row 2 (WS): Ch 1. Sc in each sc across. Turn. Rows 3 and 4 form the Left Front Ridge (LFR) pattern.

Row 3: Ch 1. Working in flps only, sl st in 2nd sc and in each sc across. Sl st in turning ch. Turn.

Row 4: Ch 1. Working in rem lps of last sc row, sc in each sc across. Turn.
Rows 5 and 6 form the Cable pattern. On Row 5, you will turn the work each time a Cable is made.

Row 5: Sc in 1st st, *ch 3, sk 2 sc, sc in next sc. Turn and work 1 sc in each ch of ch-3 just made. Join to next sc with a sl st (Cable made). Turn and, working behind the Cable, 1 sc in each Row 3 sc that was skipped, sk the sc that was made after ch-3. Rep from * across row. End by working sc in last st. Ch 1, turn (44 Cables).

NOTE: In the next row, you will work a sc in the 1st and last sts, and 3 sc evenly spaced behind each Cable (on WS). The 3 sc behind each Cable are worked into the sc that were worked into the 2 skipped sc. Work 1 sc in one of these skipped sc and 2 sc into the other. Do not work into the sc of the Cables. Push the Cables towards the RS as you work.

Row 6: Sc in 1st sc, *2 sc in next sc, sc in next sc; rep from * across to last sc, sc in last sc. Ch 1, turn (134 sc).

Rows 7 and 8: Rep Rows 3 and 4.

DIAMOND PATTERN

Rows 9 and 10: Ch 1. Sc in each sc across row. Turn.

Row 11: Ch 1. Sc in 1st st, fptr in the 4th sc on Row 8. Sk next Row 10 st, sc in the next 4 sts. [Fptr in Row 8 sc next to last fptr made, sk next 4 sc on Row 8, fptr in next st. On current row sk 2 Row 10 sts, sc in next 4 sts] across row, fptr in sc next to last fptr made. Sk next Row 10 st, sc in last st. Turn.

Rows 12–14: Ch 1. Sc in each st across. Turn.

Row 15: Ch 1. Sc in 1st 3 sc. Fptr around sc 3 rows below and directly above 1st fptr of Row 11, fptr around sc 3 rows below and directly above next fptr of Row 11. *Sc in next 4 sts. *[Fptr around sc 3 rows below and directly above next fptr of Row 11] twice. Sc in next 4 sts. Rep from * across row, ending last rep by working sc in last 3 sts. Turn.

Rows 16–18: Ch 1. Sc in each st across. Turn.

Row 19: Ch 1. Sc in 1st sc, fptr around sc 3 rows below and directly above 1st fptr of Row 15. Sk next Row 19 sts, sc in next 4 sts. Fptr around sc 3 rows below and directly above next Row 15 fptr around next sc. *Fptr around sc 3 rows below and directly above next fptr of Row 15. Sc in next 4 sts. Fptr around sc 3 rows below and directly above next fptr of Row 15. Rep from * across row, sk next Row 19 st, 1 sc in last st. Turn.

Rows 20–47: Rep Rows 12–19 three more times, then rep Rows 12–15 once more.

Blanket should measure 5 Diamonds long and 22 Diamonds across.

Row 48: Ch 1. Sc in each st across row. Turn.

Rows 49–54: Rep Rows 3–8.

CENTER SAILBOAT PATTERN

Change to medium hook.

Rows 1–4: Ch 1. Sc in each sc across row. Turn.

Row 5 (RS): Ch 1. Sc in 8 sc, *[pc in next st, sc in next st] 3 times, pc in next st, 1 sc in next 9 sc. Rep from * across row, ending last rep with sc in last 7 sc. Turn.

Row 6: Ch 1. Sc in each sc and pc across row. Turn.

Row 7: Ch 1. Sc in 7 sc, *[pc in next st, sc in next st] 4 times, pc in next st, 1 sc in next 7 sc. Rep from * across row, ending last rep with sc in last 6 sc. Turn.

Row 8: Rep Row 6.

Row 9: Ch 1. Sc in 11 sc, *1 pc in next sc, 1 sc in next 15 sc. Rep from * across row, ending last rep with 1 pc in next st, sc in last 10 sc. Turn.

Row 10: Rep Row 6.

Row 11: Ch 1. Sc in 5 sc, *[pc in next st, sc in next st] 3 times, pc in next st, 1 sc in next 9 sc. Rep from * across to last st. Sc in last st. Turn.

Row 12: Rep Row 6.

Row 13: Ch 1. Sc in 7 sc, *[pc in next st, sc in next st] twice, pc in next st, 1 sc in next 11 sc. Rep from * across row, ending last rep with sc in last 10 sc. Turn.

Row 14: Rep Row 6.

Row 15: Ch 1. Sc in 9 sc, *pc in next st, sc in next st, pc in next st, 1 sc in next 13 sc. Rep from * across row, ending last rep with sc in last 10 sc. Turn.

Row 16: Rep Row 6.

Row 17: Ch 1. Sc in 11 sc, *pc in next sc, 1 sc in next 15 sc. Rep from * across row, ending last rep with sc in last 10 sc. Turn.

Row 18: Rep Row 6.

Rows 19–22: Ch 1. Sc in each st across row. Turn.

TOP PANEL

Change to gauge hook.

Rep Rows 3–54 of Bottom Panel instructions. Do not finish off.

EDGING

Rnd 1: Ch 1. *Sc in each sc across row. At end of row, ch 1, sc again in same sp (corner made). Sc evenly across edge of blanket. At corner, ch 1 and sc in same sp as last sc. Rep from * once around the perimeter of blanket. Connect with a sl st to 1st sc of perimeter rnd. Do not turn.

Change to smallest hook.

Rnd 2: Ch 1. Sc in 1st st, ch 3, dc in same st as 1st sc, *sk next st, sc in next st, ch 3, dc in same st as sc. Rep from * around the edge of the blanket. Connect with a sl st to 1st sc of rnd. Finish off.

finishing

Weave in ends and block if needed.

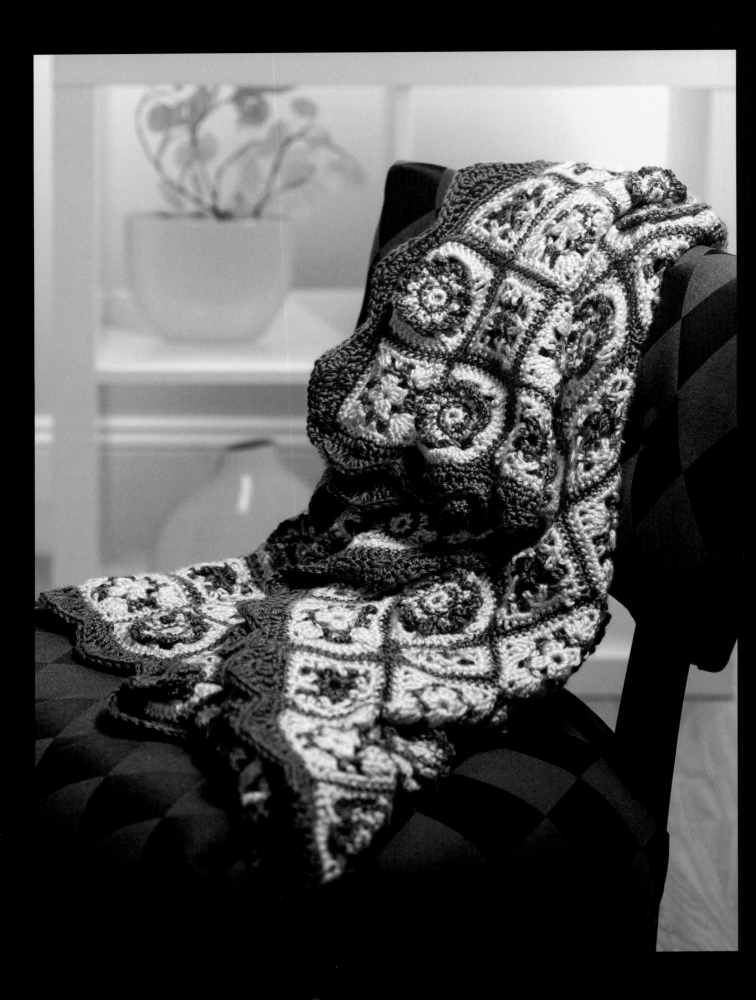

FRENCH COUNTRY
afghan

DESIGNED BY **ELLEN GORMLEY**

Imagine for a moment, an elegant table and chairs set in an open kitchen in the French countryside. The curtains billow with the breeze; succulent berries tumble out of a bowl next to a bright bunch of flowers. Designer Ellen Gormley was inspired by just such an image to create this gorgeous blanket fit for a home in the south of France.

FINISHED SIZE

41" × 57" (104 cm × 145 cm).

YARN

Worsted weight (#4 Medium).

SHOWN HERE: Caron Simply Soft (100% acrylic; 364 yd [333 ml/7 oz [198 g]): #9945 sunshine (A), 4 skeins; #9710 country blue (B), 4 skeins.

HOOK

Size H/8 (5 mm) crochet hook or any size to obtain gauge.

Size I/9 (5.5 mm) crochet hook or any size to obtain gauge.

Size K/10½ (6.5 mm) crochet hook or any size to obtain. gauge.

NOTIONS

Yarn needle.

GAUGE

Each complete square = 3½" (9 cm).

NOTES

✤ For this project, it's helpful to do a swatch of each motif, changing hooks so the end result is that each square is the same size as the other two. All three squares must be the same size.

✤ All rounds are worked on the right side. Make one of each motif first, noting the hook size used. Adjust hooks to get all three motifs the same size. Likely, Pick a Posie will require a smaller hook, like a H or I. Stain Berry and Chair Back will require a larger hook, like a J or K. Do not begin to produce motifs until you have worked out the sizing.

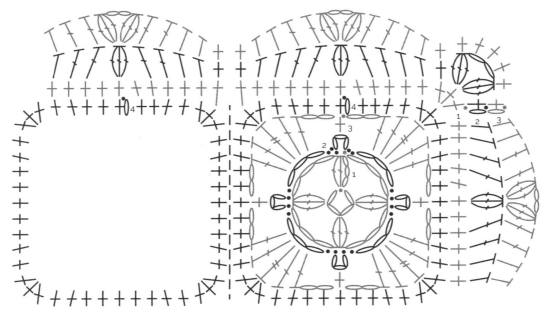

EDGING STITCH DIAGRAM

motif A

CHAIR BACK

With medium hook and color B, ch 3, join with sl st to form ring.

Rnd 1: Ch 1, (sc, ch 5) 4 times in ring; join with sl st in top of beg-sc—4 ch-5 sp and 4 sc. Fasten off.

Rnd 2: Join A with sc in any ch-5 sp, *ch 2, dc2tog placing first leg in same ch-5 sp and 2nd leg in next ch-5 sp, ch 2**, sc in ch-5 sp; rep from * 2 times, rep from * to ** once; join with sl st in top of beg-sc, do not fasten off—4 sc, 4 dc2tog, 8 ch-2 sp.

Rnd 3: Ch 1, 3 sc in first st, *3 sc in next ch-2 sp, sc in next st, 3 sc in next ch-2 sp**, 3 sc in next st; rep from * 2 more times, rep from * to ** once; join with sl st in first sc—40 sc. Fasten off.

Rnd 4: Join B with sc where previously fas-tened off, *3 sc in next st, sc in next 9 sts; rep from * 2 more times, 3 sc in next st, sc in last 8 sts; join with sl st in beg-sc—48 sc. Fasten off.

motif B

STAIN BERRY (MAKE 55)

With largest hook and color A, ch 4, join with sl st to form ring.

Rnd 1: Beg-cl in ring, ch 3, (cl, ch 3) 3 times in ring; join with sl st in top of beg-cl—4 cl and 4 ch-3 sps. Fasten off.

Rnd 2: Join color B with sl st in any ch-3 sp; *ch 3, sl st in same sp, (sl st, ch 3, sl st) in next cl**, sl st in next ch-3 sp; rep from * 2 more times; rep from * to ** once; join with sl st in first sl st—8 ch-3 sps. Fasten off.

Rnd 3: Join A with sc in ch-3 sp over any cl; *ch 2, (2 dc, tr, 2 dc) in next ch-3 sp, ch 2**, sc in next ch-3 sp; rep from * 2 more times, rep

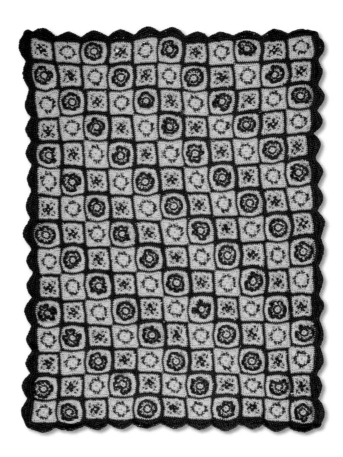

from * to ** once, join with sl st in first sc, do not fasten off—4 sc, 8 dc, 4 tr, 8 ch-2 sps.

Rnd 4: Ch 1, sc in same st; *2 sc in ch-2 sp, sc in next 2 sts, 3 sc in next st, sc in next 2 sts, 2 sc in ch-2 sp**, sc in next st; rep from * 2 more times; rep from * to ** once; join with sl st in first sc—48 sc. Fasten off.

motif C

PICK A POSIE (MAKE 55)

With smallest hook and color A, ch 4 join with sl st to form ring.

Rnd 1: Ch 1, 8 sc in ring; join with sl st in beg-sc—8 sc. Fasten off.

Rnd 2: Join B with sc in any st, sc in same st; 2 sc in each of next 7 sts; join with sl st in first sc—16 sc. Fasten off.

Rnd 3: Join A with sc in any st, ch 3; (sc, ch 3) in each of next 15 sts; join with sl st in first sc—16 sc, 16 ch-3 sps. Fasten off.

Rnd 4: Join B with sc in any sc, ch 4; *sc in next sc, ch 4, rep from * 14 times; join with sl st in first sc—16 sc, 16 ch-4 sp. Fasten off.

Rnd 5: Working behind sts in round 4, join A with sc in any ch-3 sp of round 3; *ch 6, sk all sts on round 4, sk 3 ch-3 sps on round 3**, sc in next ch-3 sp of round 3, rep from * 2 times; rep from * to ** once; join with sl st in first sc, do not fasten off—4 sc, 4 ch-6 sps.

Rnd 6: Ch 3 (counts as dc), 2 dc in same st; *7 dc in next ch-6 sp, 3 dc in next st; rep from * 2 times, 7 dc in next ch-6 sp; join with sl st in top of beg ch-3—40 dc. Fasten off.

Rnd 7: Join B with sc in middle dc of 3-dc corner, 2 sc in same st; *sc in next 9 sts, 3 sc in next st; rep from * 2 times, sc in last 9 sts; join with sl st in beg-sc—48 sc. Fasten off.

A	B	C	A	B	C	A	B	C	A	B
C	A	B	C	A	B	C	A	B	C	A
B	C	A	B	C	A	B	C	A	B	C
A	B	C	A	B	C	A	B	C	A	B
C	A	B	C	A	B	C	A	B	C	A
B	C	A	B	C	A	B	C	A	B	C
A	B	C	A	B	C	A	B	C	A	B
C	A	B	C	A	B	C	A	B	C	A
B	C	A	B	C	A	B	C	A	B	C
A	B	C	A	B	C	A	B	C	A	B
C	A	B	C	A	B	C	A	B	C	A
B	C	A	B	C	A	B	C	A	B	C
A	B	C	A	B	C	A	B	C	A	B
C	A	B	C	A	B	C	A	B	C	A
B	C	A	B	C	A	B	C	A	B	C

CONSTRUCTION DIAGRAM

assembly

With yarn needle and B, with right sides facing each other, through both loops and both thicknesses, whipstitch motifs together according to the Construction Diagram above.

EDGING

NOTE: All edging rounds are worked on the right side.

Rnd 1: With B, and largest hook, join with sc in middle sc of a corner starting a short side, 2 sc in same st; *sc in each st across, taking care to work 13 sc across side of each motif (including one sc from corner on end motifs)**, place 3 sc in middle sc of 3-sc corner; rep from * around, ending last rep at **; join with sl st in first sc, do not fasten off—680 sc.

Rnd 2: Ch 1, sc in first sc, **(cl, ch 2, cl) in next sc; *sc in next st, hdc in each of next 2 sts, dc in each of next 2 sts, sk 1 st, cl in next st, sk 1 st, dc in each of next 2 sts, hdc in each of next 2 sts, sc in next st; rep from * across to next corner; rep from ** around, omitting last sc; join with sl st in first sc. Do not fasten off.

Rnd 3: Ch 1, sc in first sc, **sc in next cl, 3 sc in next ch-2 sp, sc in next cl; *sc in next st, hdc in each of next 2 sts, dc in each of next 2 sts, (cl, ch 2, cl) in next cl, dc in each of next 2 sts, hdc in each of next 2 sts, sc in next st; rep from * across to next corner; rep from ** around, omitting last sc; join with sl st in first sc. Fasten off.

finishing

Weave in all ends.

OPTIONAL EDGINGS

SPADE

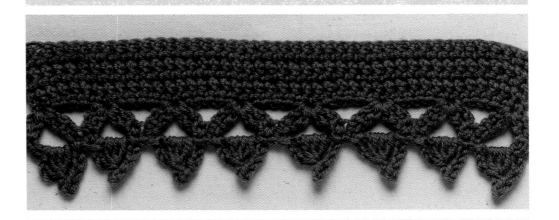

Multiple of 6 + 1 sts.

Swatch: (6 × 10) + 1 = 61 sts.

Ch 62 for swatch as shown.

Row 1: Sc in 2nd ch from hook and in each ch across, turn—61 sc.

Rows 2–6: Ch 1, sc in each st across, turn.

EDGING

Row 1 (WS): Ch 4, tr in same st (counts as 2-tr cl), ch 4, 2-tr cl in same st, *sk 5 sts, (2-tr cl, ch 4, 2-tr cl) in next st; rep from * across, turn.

Row 2: Ch 1, sc in first st, *(sl st, ch 3, 3-dc cl, ch-3 picot, ch 3, sl st) in next ch-4 sp**, sc2tog over next 2 sts; rep from * across, ending last rep at **, sc in last st.

Fasten off.

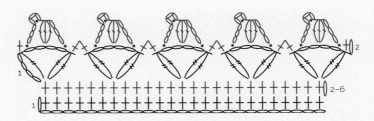

CIRCLE COINS

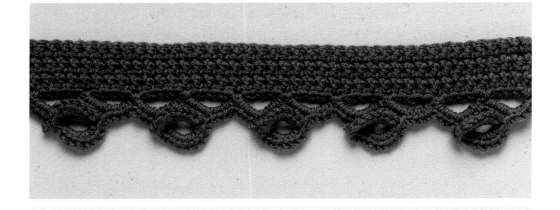

Multiple of 8 + 1 sts.

Swatch: (8 × 8) + 1 = 65 sts.

Ch 66 for swatch as shown.

Row 1: Sc in 2nd ch from hook and each ch across, turn—65 sc.

Rows 2–6: Ch 1, sc in each st across, turn.

EDGING

Row 1: Ch 1, sc in first st, *ch 5, sk 3 sts, sc in next st; rep from * across, turn.

Row 2: Ch 1, *5 sc in next ch-5 sp, ch 10, sl st in side of last sc worked, work 4 more sc in same ch-5 sp, 5 sc in next ch-5 sp, turn, 9 sc in top of last ch-10 lp, turn, 9 sc in bottom of ch-10 lp, sl st in side of last sc worked in ch-5 sp, 4 more sc in same ch-5 sp; rep from * across.

Fasten off.

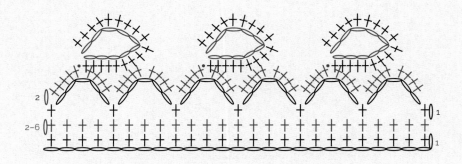

BIRCH SCALLOPS

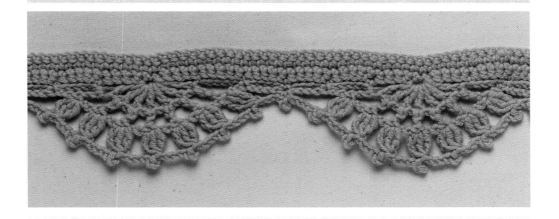

Multiple of 30 + 1 sts.

Swatch: (30 × 3) + 1 = 91 sts.

Ch 92 for swatch as shown.

Row 1: Sc in 2nd ch from hook and each ch across, turn—91 sc.

Rows 2–3: Ch 1, sc in each st across.

EDGING

Row 1 (RS): Ch 1, sc in first sc, *[ch 4, sk 4 sts, sc in next st] 2 times, ch 1, sk next 4 sts, (tr, ch 1) 7 times in next st, sk next 4 sts, sc in next st, [ch 4, sk 4 sts, sc in next st] 2 times; rep from * across, turn.

Row 2: Ch 1, sc in first sc, *ch 4, sk next ch-4 sp, sc in next sc, ch 2, [tr in next tr, ch 2] 7 times, sk next ch-4 sp, sc in next sc, ch 4, sc in next sc; rep from * across, turn.

Row 3: Ch 1, (sc, ch-3 picot, sc) in first sc, * [ch 3, ch-3 picot, 3-tr cl in next tr) 7 times, ch 3, sk next ch-4 sp, (sc, ch-3 picot, sc) in next sc; rep from * across, turn.

Fasten off.

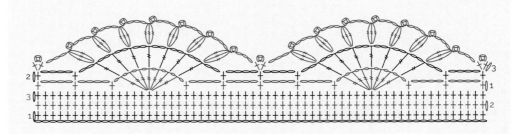

TEXTURED WAVES

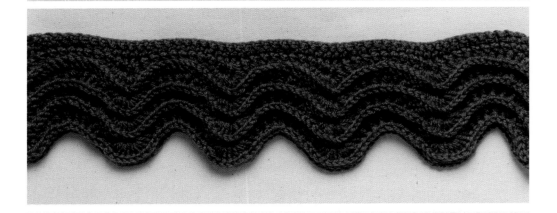

Multiple of 9 sts, grows into multiple of 17 sts.

Swatch: (9 × 5) = 45 sts; grows to (17 × 5) = 85 sts

Ch 46 for swatch as shown.

Row 1: Sc in 2nd ch from hook and in each ch across, turn—45 sts.

Rows 2–3: Ch 1, sc in each st across, turn.

EDGING

Row 1 (WS): Ch 3 (counts as dc), 4 dc in first st, dc in each of next 7 sts, 5 dc in next st, *5 dc in next st, dc in each of next 7 sts, 5 dc in next st; rep from * across, turn—85 sts.

Row 2: Ch 1, fpsc in each st across, turn.

Row 3: Ch 3 (counts as dc), working in front of fpsc row, in tops of sts 2 rows below, 4 dc in first st, (sk next st, dc in next st) 7 times, 5 dc in next st, *5 dc in next st, (sk next st, dc in next st) 7 times, 5 dc in next st; rep from * across, turn.

Row 4: Rep Row 2.

Rows 5–8: Rep Rows 3–4 twice.

Fasten off.

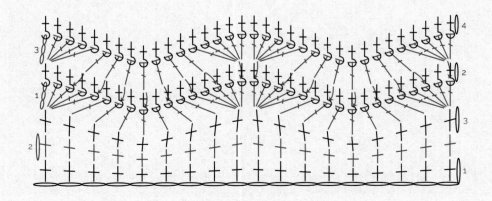

FOUNDATION PETAL

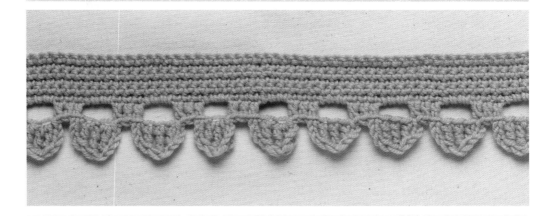

Multiple of 6 + 3 sts.

Swatch: (11 × 6) + 3 = 69 sts.

Ch 70 for swatch as shown.

Row 1: Sc in 2nd ch from hook and each ch across—69 sts.

Rows 2–6: Ch 1, sc in each st across.

EDGING

Row 1: Ch 3 (counts as dc), dc in each of next 2 sts, *ch 3, etr in 3rd ch from hook, edtr in base of last st, etr in base of last st, ch 3, sk 3 sts in prev row, dc in each of next 3 sts; rep from * across. Fasten off.

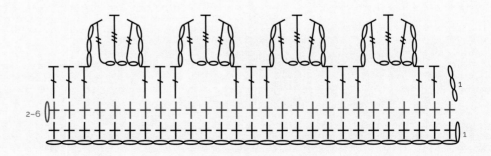

EDGING AROUND
THE CORNER

There are a couple of ways to turn corners in a rectangular piece when applying an edging. In any case, you need to take into account that it takes more stitches to turn a corner with the edging remaining flat than it does to work the edging in a straight line, so you almost always need to work increases at the corner and/or on either side of it.

The most straightforward way to add fullness in a pattern involving a stitch repeat is to increase for a full additional repeat on either side of the corner on the first row or round of the edging. For example, let's say your edging-stitch repeat is 5 stitches. Work a round of single or double crochet and increase at the corners to accommodate an additional repeat on either side. You can do this one of two different ways:

Work 3 stitches each in the 2 stitches on either side of the center corner stitch and in the center corner stitch for a total of 15 stitches (increasing by 2 full pattern repeats).

Or, for the 5 stitches before and 5 stitches after the corner, work 2 stitches in each stitch for a total of 20 stitches (4 repeats of the 5-stitch repeat of the edging on the subsequent rows/rounds).

Once this set-up row is established, you are ready to work the edging rows or rounds in pattern without needing to alter for corner fullness.

Alternatively, you can insert an extra repeat little bits at a time at the corners to eventually create a full extra repeat of the stitch pattern. This works well if the edging consists of multiple rows or rounds, but sketching the edging chart to figure out how to gradually add stitches to replicate the growth of an additional stitch pattern repeat is helpful.

One final approach is to increase in simple stitches at the corner rather than in the pattern stitch, but it will stand out as a wedge against the rest of the edging pattern; that said, it could add a welcome decorative touch.

If you are making the edging separate from the fabric to apply later, you could even gather or pleat the edging to create the fullness required for turning the corner.

DECO SCALLOPS

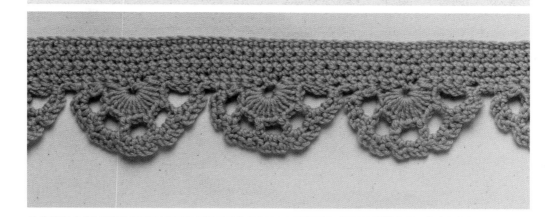

Multiple of 13 sts.

Swatch: (13 × 5) = 65 sts.

Ch 66 for swatch as shown.

Row 1: Sc in 2nd ch from hook and in each ch across—65 sts in swatch.

Rows 2–6: Ch 1, sc in each st across.

EDGING

NOTE: Scallop begins by slip-stitching in the center of the scallop, then working back and forth on a section and gaining more of the scallop at the end of each turn.

Row 1: *Sl st in each of the first 4 sts, sk 2 sts, 15 dc in next st, sk 2 sts, sl st in next st, ch 3, sk 2 sts, sl st in next st, turn, [ch 3, sk 2 dc, dc in next dc] 5 times, sk 2 sts on prev row, sl st in next st, turn, (sc, ch 3, sc, ch 3, sc) in next 5 ch-3 sps, sl st in next sc on prev row; rep from * across.

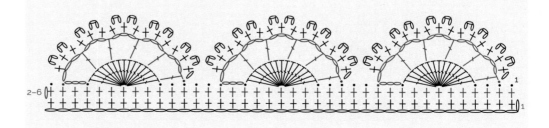

GOTHIC CATHEDRAL

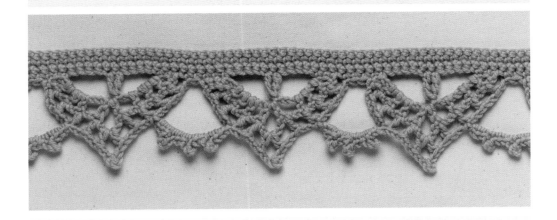

Multiple of 18 + 1 sts.

Swatch: (18 × 5) + 1 = 91.

Ch 92 for swatch as shown.

Row 1: Sc in 2nd ch from hook and in each ch across, turn—91 sc.

Rows 2–3: Ch 1, sc in each st across, turn.

EDGING

Row 1: Ch 1, sc in first 4 sts, ch 5, sk 4 sts, dc2tog over next 2 sts, *ch 5, sk 4 sts, sc in each of next 3 sts, turn, [ch 2, dc] 3 times in next ch-5 sp, ch 2, (dc, ch 5, dc) in next dc2tog, [ch 2, dc] 3 times in next ch-5 sp, sk next 2 sc, sl st in next sc, turn, [ch 2, dc in next dc] 4 times, ch 2, (dc, ch 5, dc) in next ch-5 sp, [ch 2, dc in next dc] 4 times, sc in each of next 5 sc in prev row, *ch 5, sk 4 sts, dc2tog over next 2 sts, ch 5, sk 4 sts, sc in each of next 3 sts, turn, [ch 2, dc] 3 times in next ch-5 sp, ch 2, (dc, ch 5, dc) in next dc2tog, [ch 2, dc] 3 times in next ch-5 sp, sk next 2 sc, sl st in next sc, turn, [ch 2, dc in next dc] 3 times, ch 9, turn, sk next 5 ch-2 sps, sl st in next dc, turn, ([3 sc, ch-3 picot] 3 times, 3 sc) in next ch-9 lp, sl st in next dc, ch 2, dc in next dc, ch 2, (dc, ch 5, dc) in next ch-5 sp, [ch 2, dc in next dc] 4 times**, sc in each of next 5 sc in prev row; rep from * across, ending last rep at **, sc in last sc.

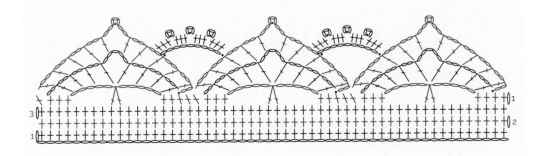

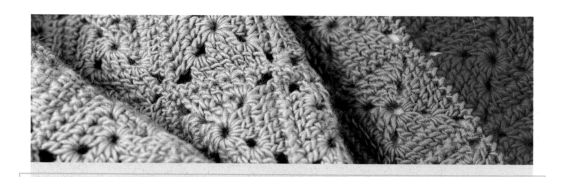

SYMBOL CROCHET

In this book, you will be using some really fun crochet techniques. There will be some crochet colorwork, granny squares and other motifs, crochet lace, and other interesting stitches. You will be aided in many of these techniques by symbol crochet. So, let's begin our journey by mastering all that symbol crochet has to offer.

symbol crochet basics

You will see crochet symbols used throughout this book. They will help you understand the instructions by giving you a visual reference for the crochet stitches and patterns you will be using. They are quite simple to follow once you have mastered the basic concepts, so read on and discover the magic of crochet symbols.

THE SYMBOLS

The key to understanding crochet symbols is that each symbol represents a crochet stitch. Let's start with the smallest stitch, the chain, by looking at the crochet symbol key on page 116. The symbol for a chain is an oval. Why an oval? Well, think about making a chain stitch; it's a simple loop pulled through another loop. That loop, which is our chain stitch, looks a lot like an oval, doesn't it? The international crochet symbols try to mimic the actual stitch as much as possible.

Let's look at a few more; you'll soon see that reading crochet symbols becomes quite intuitive. Appearing next in the stitch key is the slip stitch, which is a filled dot—the symbol is small, almost invisible, just like the stitch. Moving on, the single

= chain (ch)
• = slip st (sl st)
= single crochet (sc)
T = half double crochet (hdc)
T or T = double crochet (dc)
T or T = treble crochet (tr)
T or T = double treble crochet (dtr)
A = sc2tog
A or A = dc2tog
A = dc3tog
A = dc4tog
A = dc5tog
= sc spike
I = hdc blp
= edc
= bpdc
= fpdc

() = 2-hdc cluster
= 2-dc cluster
= 3-dc cluster
= 2-tr cluster
or or = 3-tr cluster
or = 4-tr cluster
= 5-tr cluster
= beg popcorn
= popcorn
= beg tr popcorn
= tr popcorn
= ch-3 picot
= ch-4 picot
= ch-7 picot
= ch-7 joining picot

SYMBOL CROCHET KEY

crochet is a squat cross, again just like the stitch. The half double crochet is slightly taller than the single crochet. The double crochet is taller than the half double and has an extra cross in its middle. From the double crochet up, the little crosses tell you how many yarnovers you have before you insert your hook. Go ahead; make a double crochet. Now, look at your stitch. Do you see the little horizontal line in the middle of the stitch? That is why the double crochet symbol has that little bar in the middle of its post.

The rest of the symbols fall in line with the same reasoning. If the stitch is short, the symbol will be short; if the stitch puffs out (like a cluster stitch), the symbol will as well.

Don't worry. You won't have to memorize the symbols. You can always refer to the key. In addition, there are instructions for creating the stitches provided in the glossary and also in some individual patterns (where a special stitch may be used exclusively).

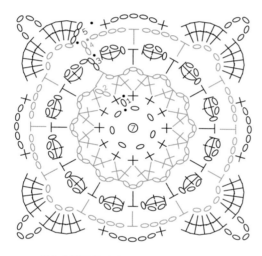

GRANNY-SQUARE EXAMPLE

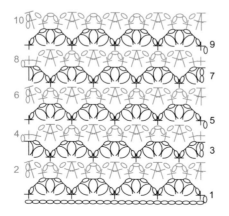

STITCH-PATTERN EXAMPLE

GRANNY-SQUARE DIAGRAMS

Now, if you'd like to try out your crochet symbol-reading skills, a granny-square diagram is the best way to get your feet wet. I like to think of granny-square diagrams as tiny maps. They show the big picture of what the motif will look like when completed, with round-by-round directions on how to get there. Let's look at the granny-square example below. To begin, you need to start in the center of the diagram, just as you would to crochet the granny square itself. Now, look at the center of the diagram; can you tell how many chains to crochet to start the motif? That's right: 7. You can see that it is 7 by looking at the circled number in the center or by counting the chain stitches surrounding it.

Here's another question for you. On Round 4 how many ch-4 sps are there? There are 12. You can tell which round is #4 by looking for the "4" at the beginning of the round or by counting the different-colored rounds up from the center. Each round is a different color and is numbered to help you keep your place. You can see that Round 4 is a blue round. To find out how many ch-4 sps there are, you just count the number around. As you can see, these little maps can come in handy while you are crocheting because you can check your progress as you go.

STITCH-PATTERN DIAGRAMS

Stitch-pattern diagrams are not that different from granny square diagrams. The key difference is that, instead of crocheting in the round, you crochet back and forth in turned rows.

Therefore, when you are reading the diagram, you need to start at the bottom foundation chain and crochet as many chains as the diagram shows. Then, following the symbol key, crochet the stitches you see for the first row, working from right to left. At the end of the row, turn and continue crocheting the stitches you see for the second row, reading from left to right. The numbers on the diagram let you know where the beginning of each row is, so you can keep track of where you are. Each diagram has a different color for each row, so it's easy to keep track of the row you are on.

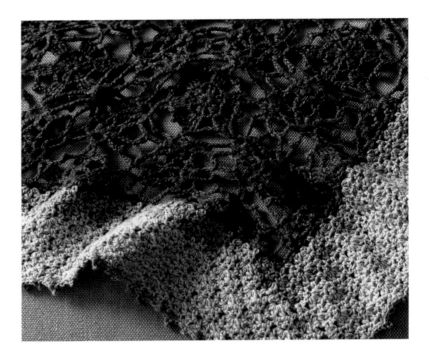

symbol crochet rules

Now that you are familiar with the basics of symbol crochet, we are going to learn some more techniques. The catch is this: the rest of the techniques break some of the rules of symbol crochet that we just learned. Here is a list of those rules for your reference.

TOP 6 RULES OF SYMBOL CROCHET

1 Each symbol represents one stitch to crochet (see page 116 for a crochet symbol key; refer to the glossary, beginning on page 120, for stitch instructions).

2. Each symbol is a tiny stick diagram of the actual stitch. The taller and/or fatter the symbol, the taller and/or fatter the stitch it represents.

3 Each row or round is a different color in the diagrams to help you keep track of which one you are working on.

4 Each row or round has a number next to the beginning turning chain to indicate the start of the row or round.

5 Granny-square and motif diagrams start in the center and increase outward just as you would crochet.

6 Stitch-pattern diagrams work rows back and forth and will indicate in brackets how many stitches or rows to repeat in a design.

ABBREVIATONS

| | | | | | | |
|---|---|---|---|---|---|
| **beg** | begin; begins; beginning | **inc** | increase(s); increasing; increased | **sl st** | slip(ped) stitch |
| **bet** | between | **lp(s)** | loop(s) | **sp(s)** | space(s) |
| **blo** | back loop only | **MC** | main color | **st(s)** | stitch(es) |
| **CC** | contrasting color | **m** | marker; meter(s) | **tch** | turning chain |
| **ch(s)** | chain(s) | **mm** | millimeter(s) | **tog** | together |
| **cl(s)** | cluster(s) | **p** | picot | **tr** | treble crochet |
| **cm** | centimeter(s) | **patt(s)** | pattern(s) | **WS** | wrong side |
| **cont** | continue(s); continuing | **pm** | place marker | **yd** | yard(s) |
| **dc** | double crochet | **rem** | remain(s); remaining | **yo** | yarn over |
| **dec** | decrease(s); decreasing; decreased | **rep** | repeat; repeating | ***** | repeat starting point |
| **dtr** | double treble (triple) | **rnd(s)** | round(s) | **()** | alternative measurements and/or instructions; work instructions within parentheses in place directed |
| **est** | established | **RS** | right side | | |
| **foll** | follows; following | **sc** | single crochet | **[]** | work bracketed instructions a specified number of times |
| **g** | gram(s) | **sh** | shell | | |
| **hdc** | half double crochet | **sk** | skip | | |
| | | **sl** | slip | | |

stitches

CHAIN (CH)

Make a slipknot and place it on crochet hook. *Yarn over hook and draw through loop on hook. Repeat from * for the desired number of stitches.

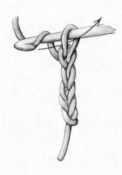

HALF DOUBLE CROCHET (HDC)

*Yarn over, insert hook in stitch (figure 1), yarn over and pull up loop (3 loops on hook), yarn over (figure 2) and draw through all loops on hook (figure 3); repeat from *.

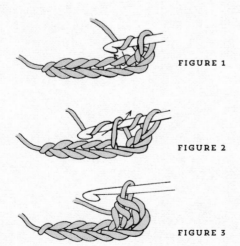

FIGURE 1

FIGURE 2

FIGURE 3

DOUBLE CROCHET (DC)

*Yarn over hook, insert hook in a stitch, yarn over hook and draw up a loop (3 loops on hook; figure 1), yarn over hook and draw it through 2 loops (figure 2), yarn over hook and draw it through remaining 2 loops on hook (figure 3). Repeat from *.

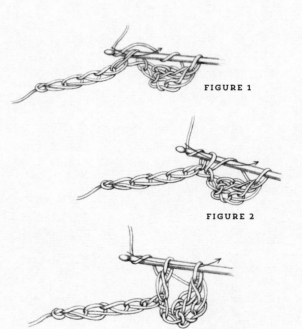

FIGURE 1

FIGURE 2

FIGURE 3

TREBLE CROCHET (TR)

*Wrap yarn around hook twice, insert hook in next indicated stitch, yarn over hook and draw up a loop (4 loops on hook; figure 1), yarn over hook and draw it through 2 loops (figure 2), yarn over hook and draw it through next 2 loops, yarn over hook and draw it through the remaining 2 loops on hook (figure 3). Repeat from *.

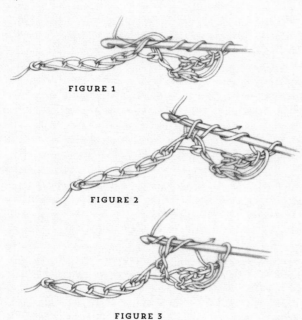

FIGURE 1

FIGURE 2

FIGURE 3

DOUBLE TREBLE CROCHET (DTR)

Yarn over hook 3 times, insert hook in a stitch, yarn over hook and draw up a loop (5 loops on hook). [Yarn over hook and draw it through 2 loops] 4 times. Repeat from *.

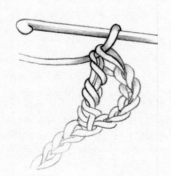

EXTENDED SINGLE CROCHET (ESC)

Insert hook in next stitch, yarn over hook, draw up a loop (2 loops on hook), yarn over hook and draw through first loop on hook, yarn over hook and draw through both loops on hook—1 esc made.

FOUNDATION DOUBLE CROCHET (FDC)

Ch 3. Yarn over, insert hook in 3rd chain from hook, yarn over and pull up loop (3 loops on hook), yarn over and draw through 1 loop (1 chain made), [yarn over and draw through 2 loops] 2 times (figure 1)— foundation double crochet. Yarn over, insert hook under 2 loops of chain at bottom of stitch just made, yarn over and pull up loop (3 loops on hook) (figure 2), yarn over and draw through 1 loop (1 chain made), [yarn over and draw through 2 loops] 2 times (figure 3). *Yarn over, insert hook under 2 loops of chain at bottom of stitch just made (figure 4), yarn over and pull up loop (3 loops on hook), yarn over and draw through 1 loop (1 chain made), [yarn over and draw through 2 loops] 2 times. Repeat from * as needed (figure 5).

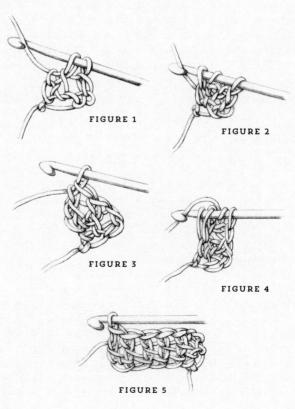

FIGURE 1

FIGURE 2

FIGURE 3

FIGURE 4

FIGURE 5

FOUNDATION HALF DOUBLE CROCHET (FHDC)

Ch 3, yarn over, insert hook in 3rd chain from hook, yarn over and pull up loop (3 loops on hook), yarn over and draw through 1 loop (1 chain made), yarn over and draw through all loops on hook—1 foundation half double crochet. *Yarn over, insert hook under the 2 loops of the "chain" stitch of last stitch and pull up loop, yarn over and draw through 1 loop, yarn over and draw through all loops on hook; repeat from * for length of foundation.

BACK POST SINGLE CROCHET (BPSC)

Insert hook from back to front, right to left, around the post of the specified stitch, yarn over hook, pull through work only, yarn over hook, and pull through both loops on hook—1 bpsc made.

BACK POST HALF DOUBLE CROCHET (BPHDC)

Yarn over hook, insert hook from back to front to back around post of corresponding stitch below, yarn over and pull up loop, yarn over hook and draw through all 3 loops on hook.

BACK POST DOUBLE CROCHET (BPDC)

Yarn over hook, insert hook from back to front, to back again around the post of stitch indicated, yarn over hook, draw yarn through stitch, [yarn over hook, draw yarn through 2 loops on hook] twice.

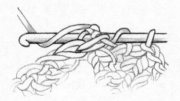

FRONT POST DOUBLE CROCHET (FPDC)

Yarn over hook, insert hook from front to back to front again around post of stitch indicated, yarn over hook and pull up a loop (3 loops on hook), [yarn over hook and draw through 2 loops on hook] twice—1 FPdc made.

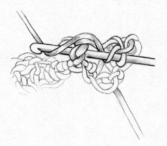

FRONT POST TREBLE CROCHET (FPTR)

Yarn over hook twice, insert hook in specified stitch from front to back, right to left, around the post (or stem). Yarn over hook, pull through work only, *yarn over hook, pull through 2 loops on hook. Rep from * twice—1 FPtr made.

REVERSE SINGLE CROCHET (REV SC)

Working from left to right, insert crochet hook in an edge stitch and pull up loop, yarn over and draw this loop through the first one to join, *insert hook in next stitch to right (figure 1), pull up a loop, yarn over (figure 2), and draw through both loops on hook (figure 3); repeat from *.

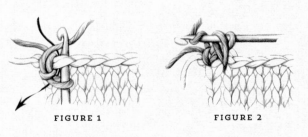

FIGURE 1 **FIGURE 2**

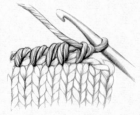

FIGURE 3

making an adjustable ring

Make a large loop with the yarn (figure 1). Holding the loop with your fingers, insert hook in loop and pull working yarn through loop (figure 2). Yarn over hook, pull through loop on hook. Continue to work indicated number of stitches in loop (figure 3; shown in single crochet). Pull on yarn tail to close loop (figure 4).

decreases

SINGLE CROCHET TWO TOGETHER (SC2TOG)

Insert hook in stitch and draw up a loop. Insert hook in next stitch and draw up a loop. Yarn over hook (figure 1). Draw through all 3 loops on hook (figures 2 and 3)— 1 stitch decreased.

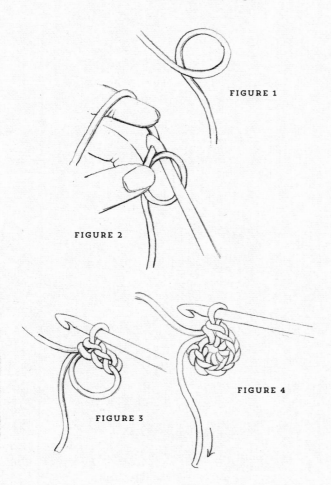

FIGURE 1

FIGURE 2

FIGURE 3

FIGURE 4

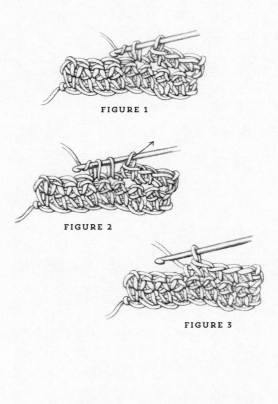

FIGURE 1

FIGURE 2

FIGURE 3

SINGLE CROCHET THREE TOGETHER (SC3TOG)

[Insert hook in next stitch, yarn over, pull loop through stitch] 3 times (4 loops on hook). Yarn over and draw yarn through all 4 loops on hook. Completed sc-3tog—2 stitches decreased.

HALF DOUBLE CROCHET TWO TOGETHER (HDC2TOG)

[Yarn over hook, insert hook in next stitch, yarn over hook and pull up loop] twice (figure 1), yarn over hook and draw through all loops on hook (figures 2 and 3)—1 stitch decreased.

DOUBLE CROCHET TWO TOGETHER (DC2TOG)

[Yarn over, insert hook in next stitch, yarn over and pull up loop (figure 1), yarn over, draw through 2 loops] 2 times (figure 2), yarn over, draw through all loops on hook (figure 3) —1 stitch decreased (figure 4).

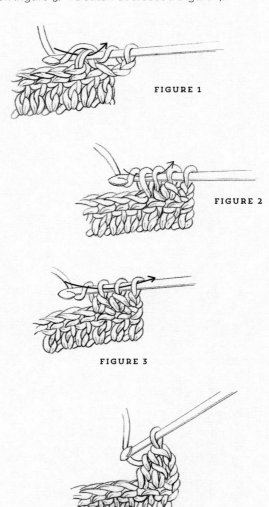

FIGURE 1

FIGURE 2

FIGURE 3

FIGURE 4

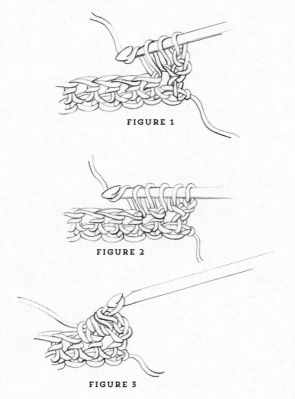

FIGURE 1

FIGURE 2

FIGURE 3

DOUBLE CROCHET THREE TOGETHER (DC3TOG)

[Yarn over, insert hook in next stitch, yarn over and pull up loop, yarn over, draw through 2 loops] 3 times (4 loops on hook), yarn over, draw through all loops on hook—2 stitches decreased.

DOUBLE CROCHET FOUR TOGETHER (DC4TOG)

[Yarn over hook, insert hook in next stitch, yarn over and pull up loop, yarn over and draw through 2 loops] 4 times, yarn over, draw through all loops on hook—3 stitches decreased.

EXTENDED SINGLE CROCHET TWO TOGETHER (ESC2TOG)

[Insert hook in next stitch, yarn over hook, draw up a loop (2 loops on hook), yarn over hook and draw through first loop on hook] twice, yarn over hook and draw through 3 loops on hook—1 esc2tog made.

seaming

SINGLE CROCHET SEAM

Place the pieces together with the wrong (WS) or right sides (RS) facing, depending on whether you want your seam to be hidden on the wrong side or show on the right side of your work. Hold the pieces in your hand with the two edges facing you.

Insert the hook through both pieces at the beg of the seam and pull up loop, chain 1. Work a row of single crochet by inserting your hook through both pieces at the same time. Complete the seam and secure the end of the seaming yarn.

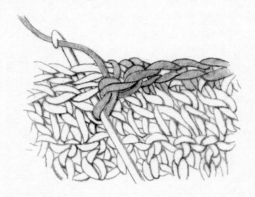

WHIPSTITCH

With right sides (RS) of work facing and working through edge stitches, bring threaded needle out from back to front, along edge of piece.

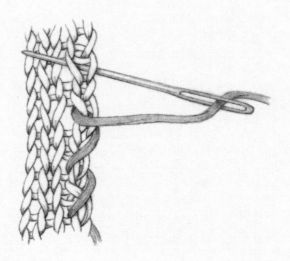

a content + ecommerce company

www.fwcommunity.com

20 19 18 17 16 5 4 3 2 1

Distributed in Canada by Fraser Direct
100 Armstrong Avenue
Georgetown, ON, Canada L7G 5S4
Tel: (905) 877-4411

Distributed in the U.K. and Europe by F&W MEDIA INTERNATIONAL
Brunel House, Newton Abbot, Devon, TQ12 4PU, England
Tel: (+44) 1626 323200, Fax: (+44) 1626 323319
E-mail: enquiries@fwmedia.com

Distributed in Australia by Capricorn Link
P.O. Box 704, S. Windsor NSW, 2756 Australia
Tel: (02) 4560 1600, Fax: (02) 4577 5288
E-mail: books@capricornlink.com.au

SRN: 16CR07
ISBN-13: 978-1-63250-359-6

CURATED BY Kerry Bogert
EDITED BY Michelle Bredeson
COVER DESIGN BY Clare Finney
INTERIOR DESIGN BY Karla Baker
PHOTOGRAPHY BY Joe Hancock (unless otherwise noted)
PRODUCTION COORDINATED BY Bryan Davidson

ADDITIONAL PHOTOGRAPHY CREDITS:
Joe Coca: pages 107–114
Sarah London: pages 88–93
Al Parrish: pages 60–63, 102–105
Corrie Schaffeld: pages 85–87, 98–100

METRIC CONVERSION		
TO CONVERT	**TO**	**MULTIPLY BY**
Inches	*Centimeters*	*2.54*
Centimeters	*Inches*	*0.4*
Feet	*Centimeters*	*30.5*
Centimeters	*Feet*	*0.03*
Yards	*Meters*	*0.9*
Meters	*Yards*	*1.1*

INDEX

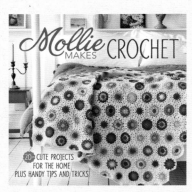
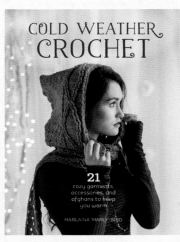
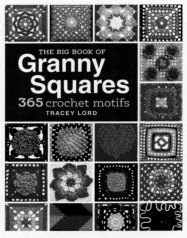